Family Album

A novel by Matt Addis

©2017 matt addis

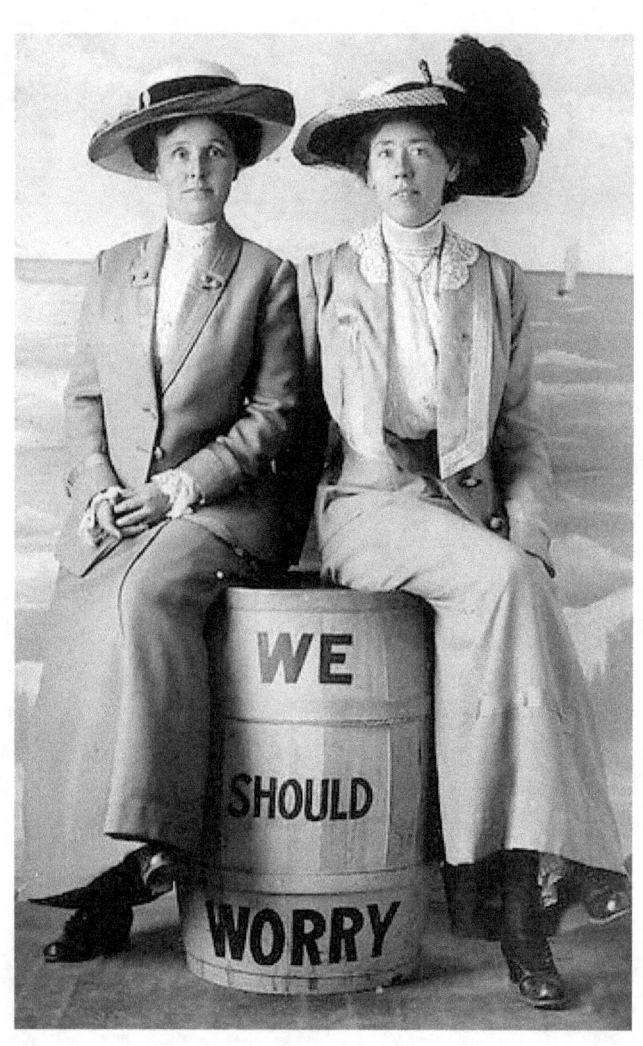

Mother with her friend hazel. Hazel was the fisherman's wife and sold eggs by the dozen at the local fair. She had three sons, each named Todd that formed a coalition of bankers in the gulf coast area under assumed names. Hazel was friendly for the most part, except during the bologna war where she betrayed us all the peanut king and we had to live in a cage for 3 weeks. She died of cancer a few years later.

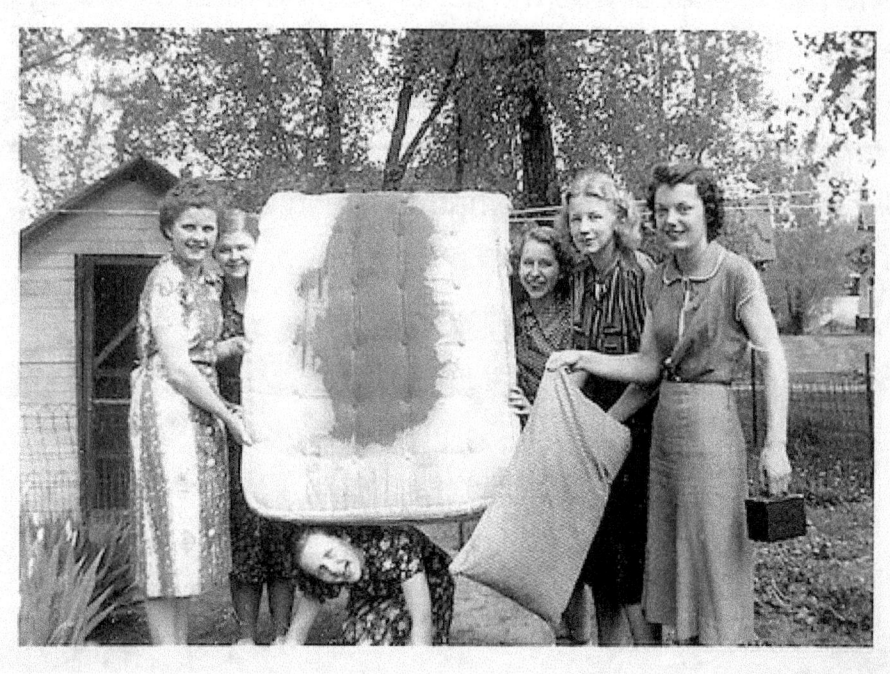

The bed where Uncle Mortimer died. He was a tyrant to my nieces and nephews and they all celebrated his demise with great gusto. He bled out in the night after a cerebral hemorrhage. Or so they say...

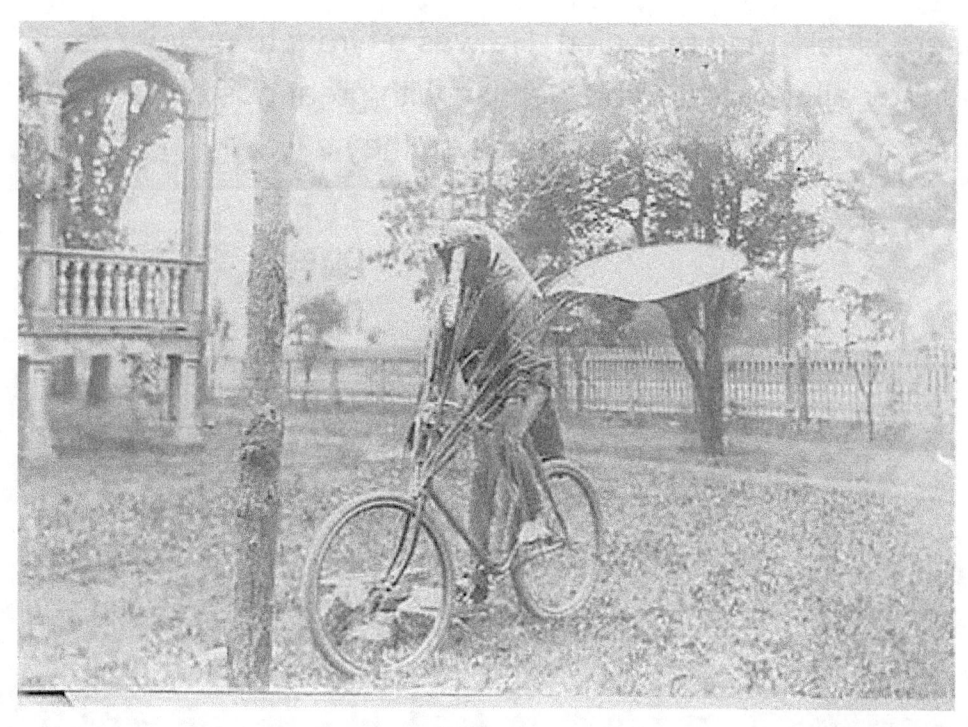

Father had some strange hobbies. He sometimes pretended he was a fly to annoy our neighbors on the south wing. He had many other strange occupations as well. Testicle surfing, ant farming, weasel collecting and pine needle macrame were also on his agenda.

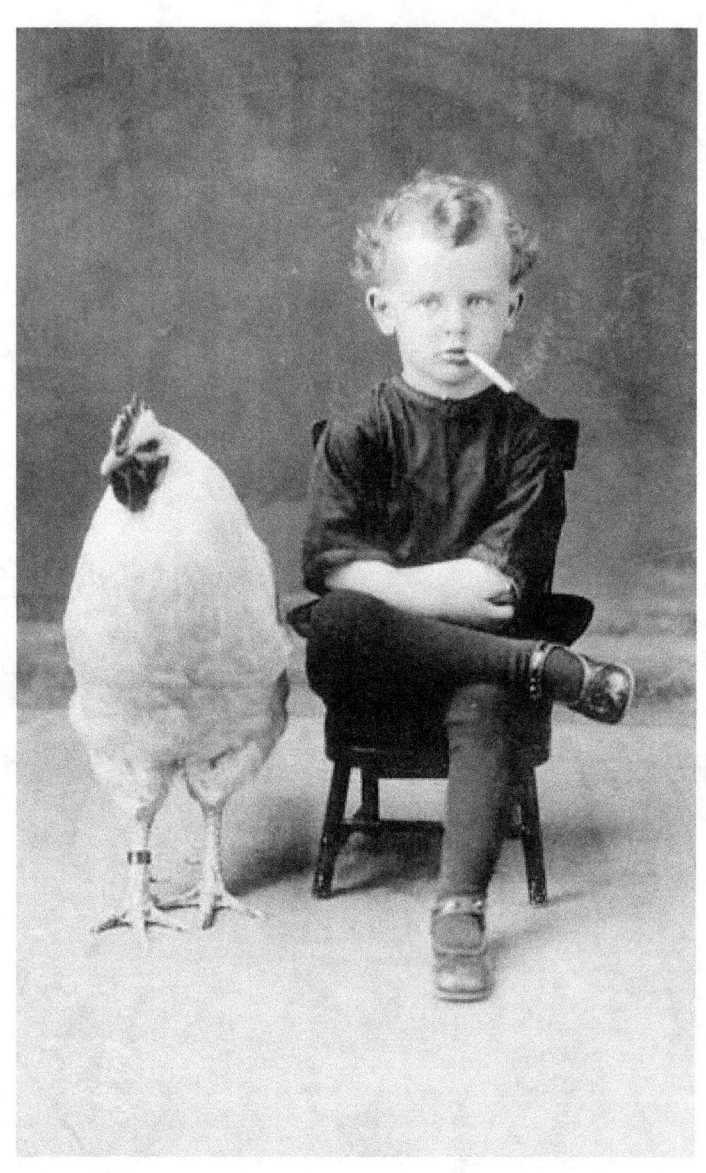

Mother and Father were deeply disturbed by my new predilection for smoking, so they hired a police officer to look after me. His name was Officer Creamington and he gave me a thrashing every time I would light a cigarette. I still retain the scars from several of those "love taps", as he called them, to this very day.

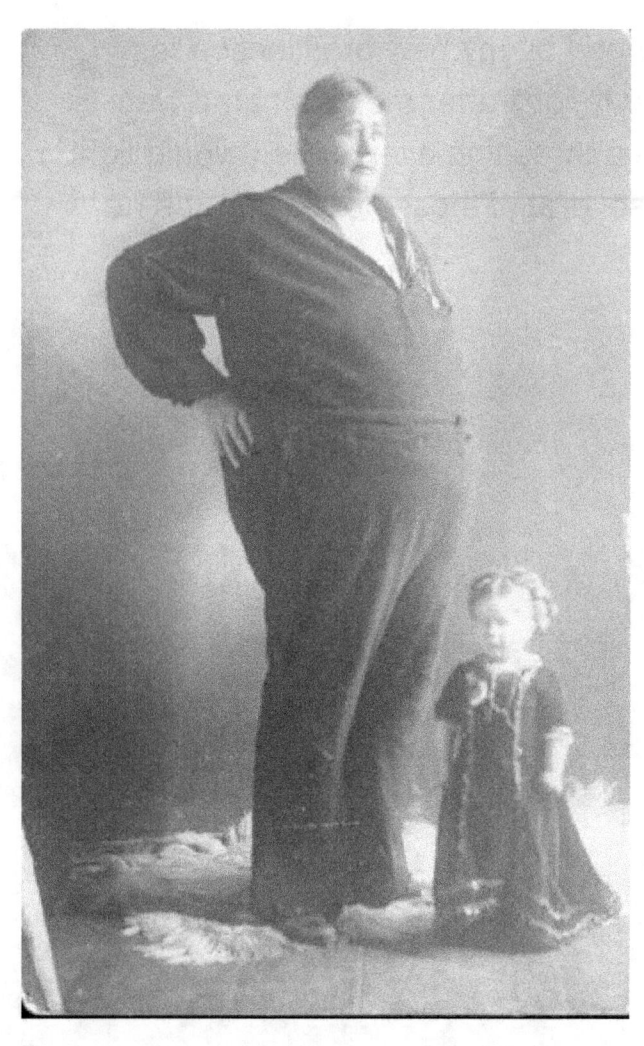

Father cut an imposing figure indeed. Here he is teaching me how to swim. He was unsuccessful, but I atleast I got some chocolate pudding out of the whole ordeal.

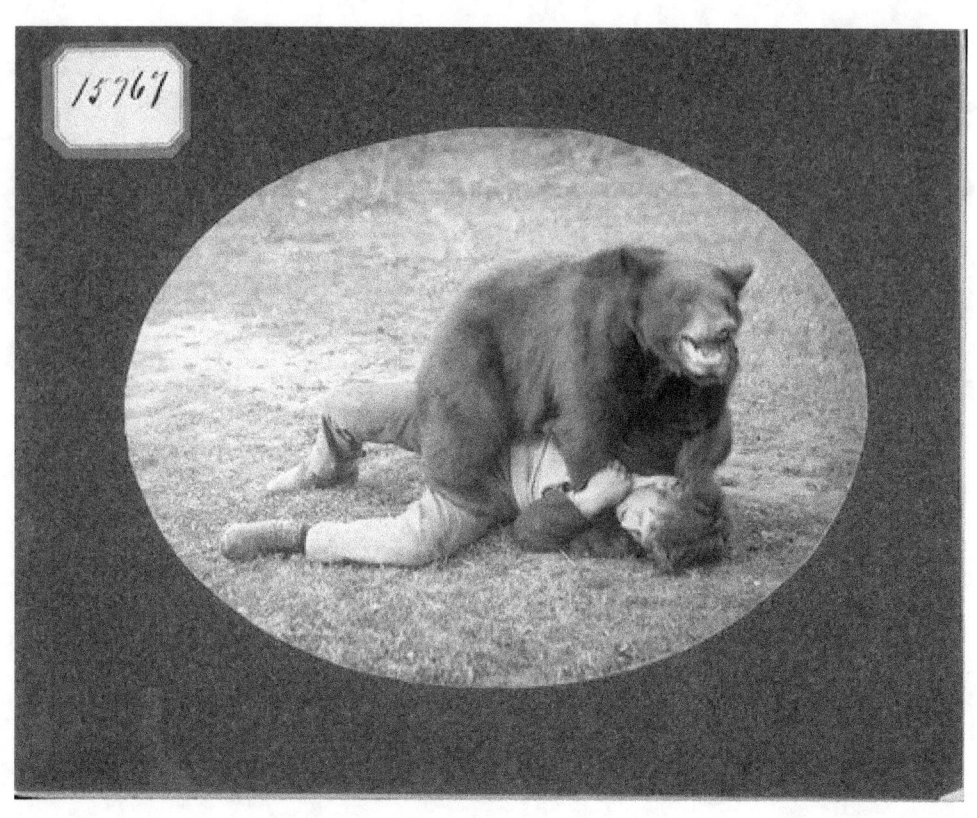

High School was a difficult time for me. I was quite unpopular and was often the subject of ridicule for my awkwardness and...unusual proportions. Nevertheless, I graduated with a 3.9 gpa and attended a prestigious school.

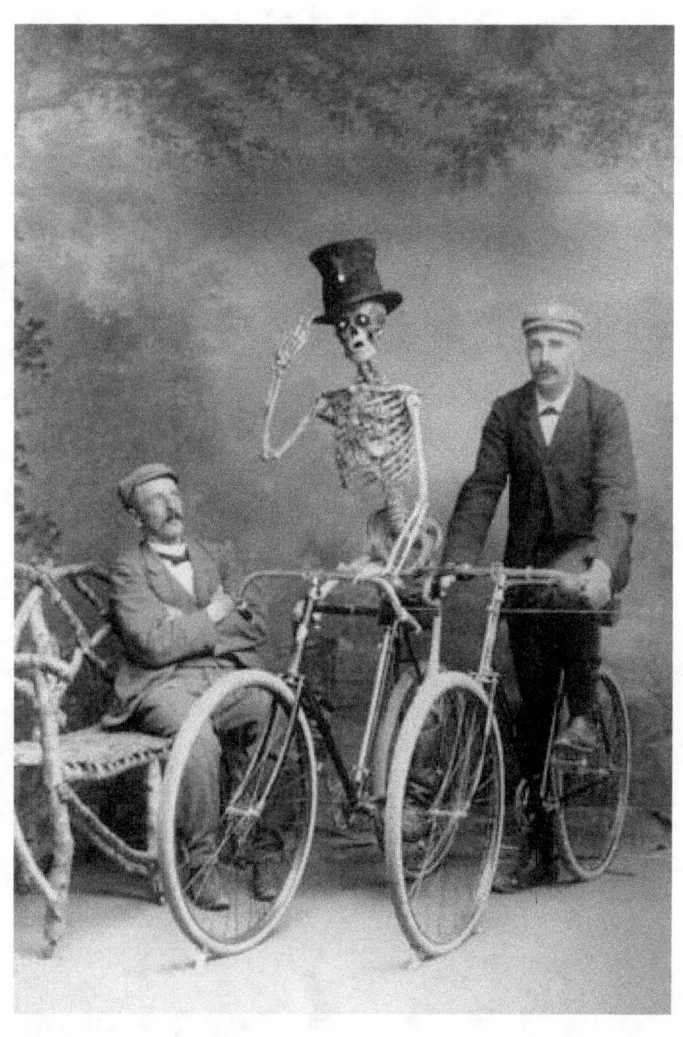

Every 3-4 months or so Uncle Ossie would drop by and give us presents. One time he gave me a rusted doorknob. I buried it in the backyard and the apple tree died.

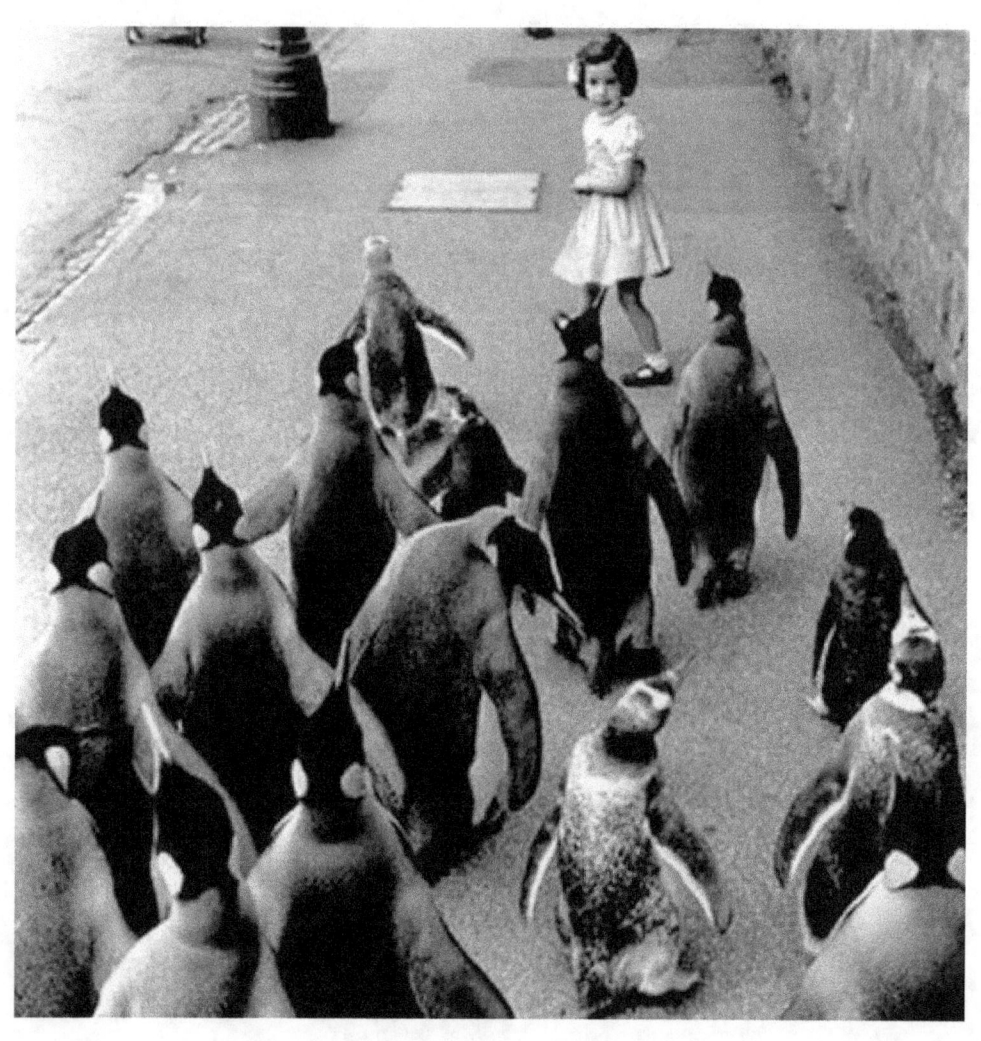

My sister was quite opposite from me in that she was one of the most popular girls in our school. She always had a crowd of followers and many I'm afraid to say were just fair weather friends. Here she is buying some ice cream with her cheerleading squad.

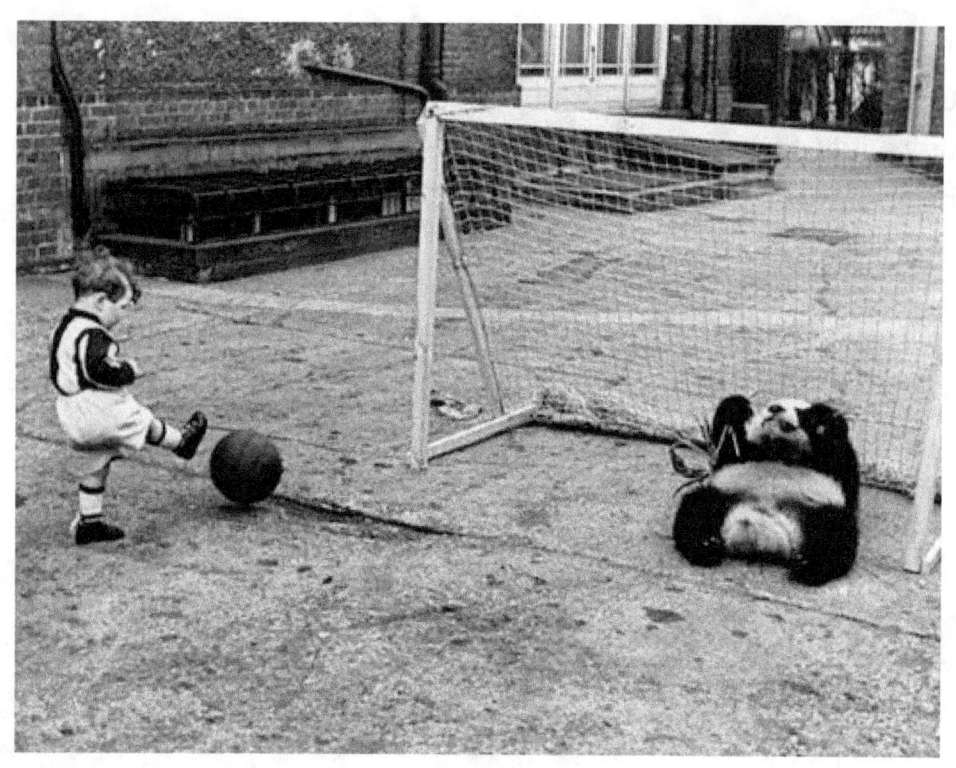

Sports were another subject I never seemed get the handle of. My cousin BIlly often taunted me and forced me to play goalie, because he said that was the position losers like me played. Billy committed suicide on Valentine's Day.

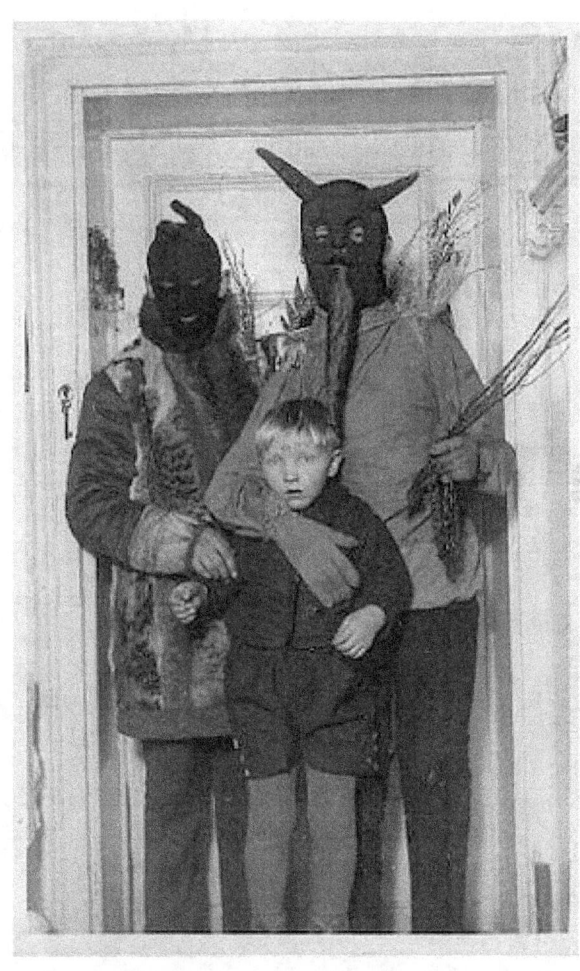

The neighborhood boys, however, were quite friendly. Even if they had some unusual pastimes.

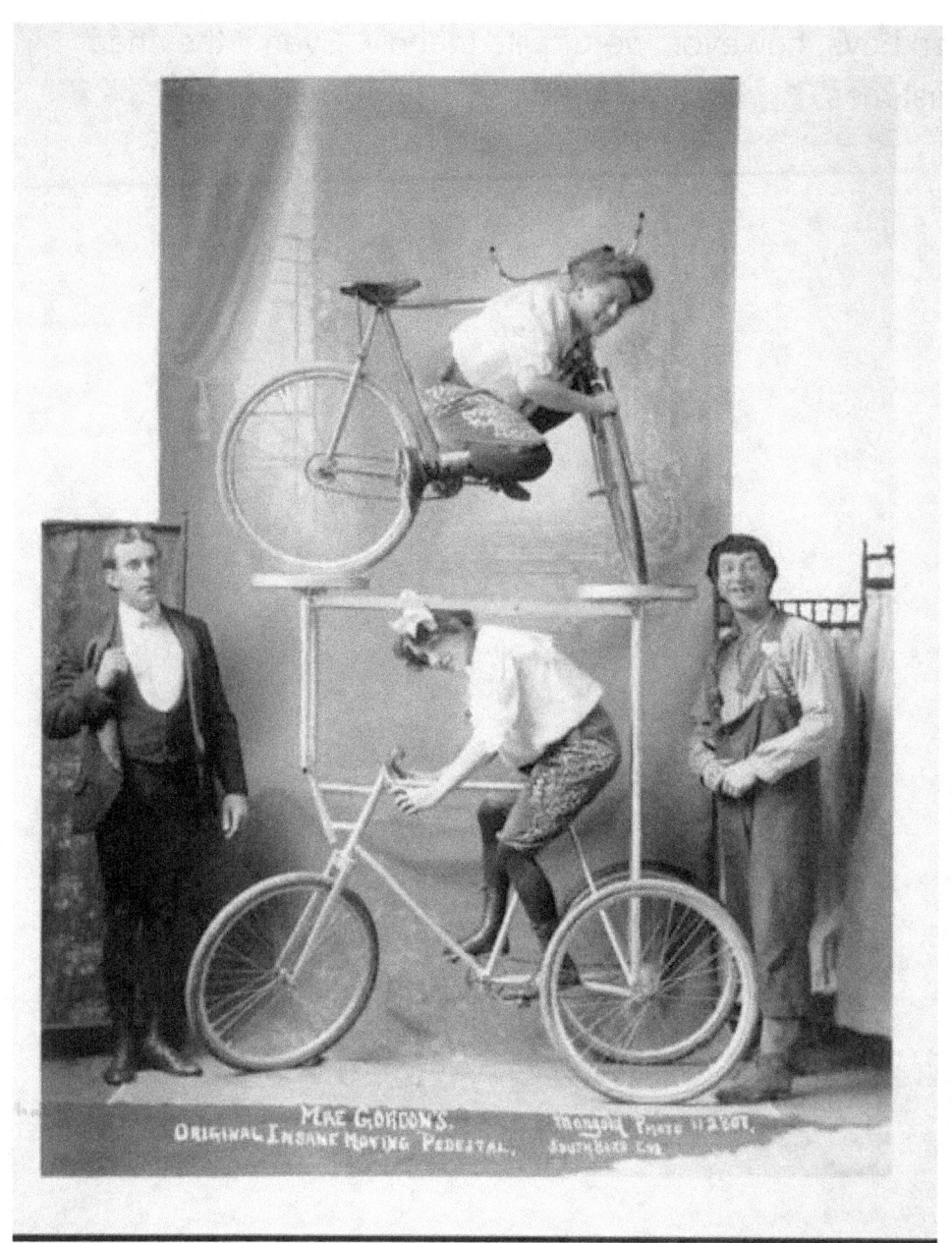

Cousin Phillip liked to perform science experiments in his spare time. This was back in the day, when the "gentleman of leisure" often was his own patron in the sciences. He discovered fascinating properties of metal, wood, and rubber. He showed me his laboratory once, it has since been destroyed.

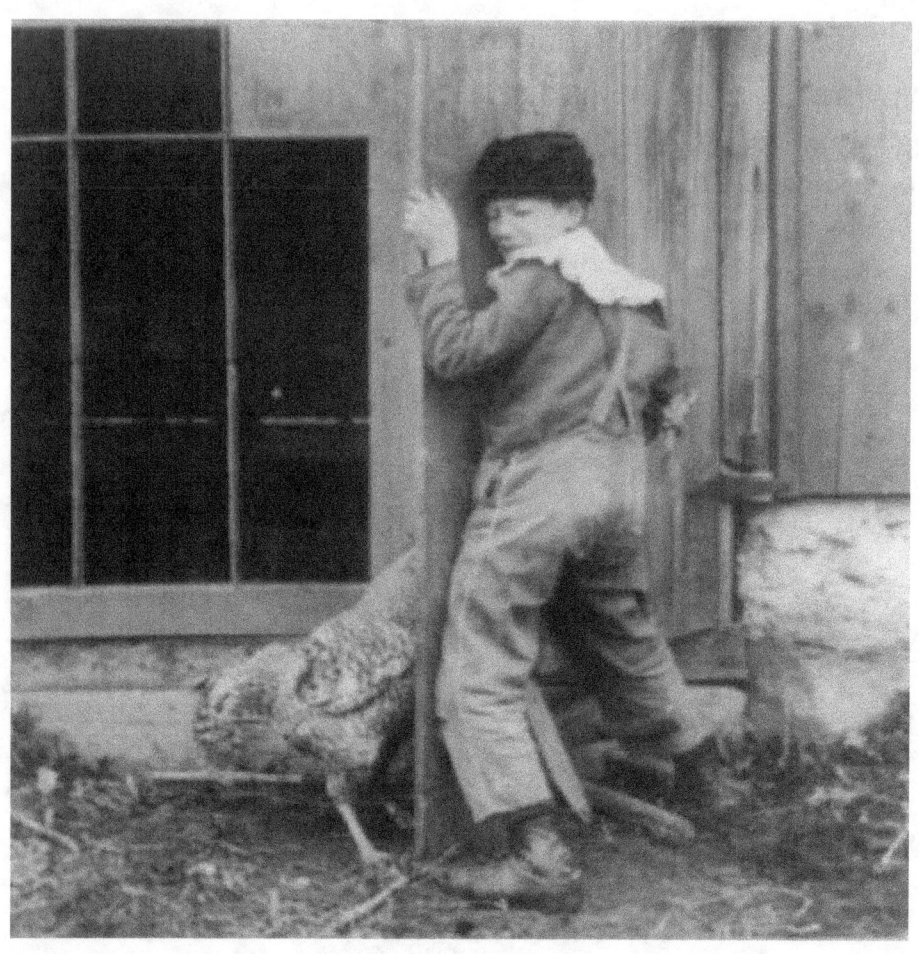

This is quite embarrassing. It's Officer Creamington delivering one of his thrashings. I remember this one. It was after I snuck in the basement for a smoke. Before I had even lit my Pall Mall, Officer Creamington was there. How I hated that man.

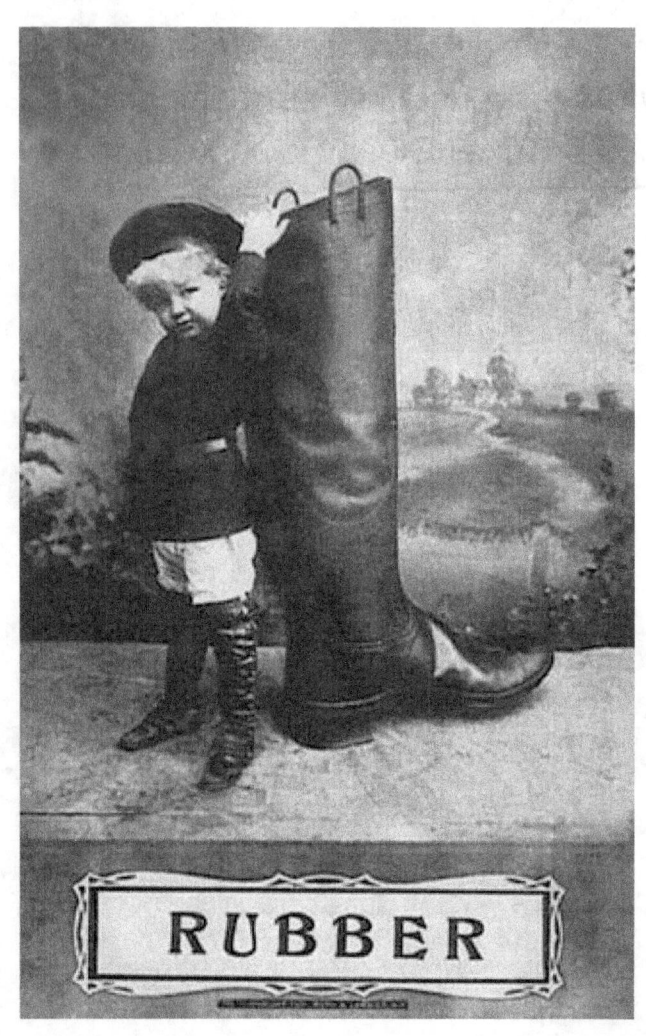

Every night from the time I was 2 to the time I was 6 I would sleep in a rubber fisherman's boot. That's where I got the childhood nickname of "Rubber".

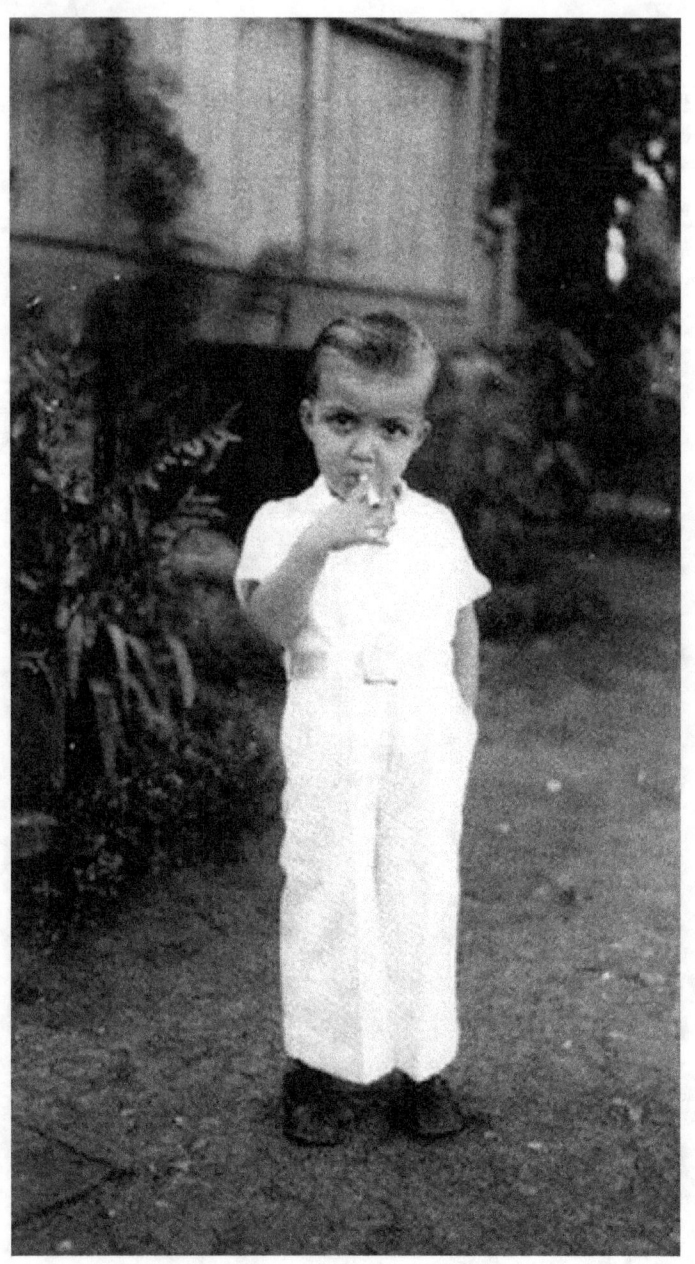

Despite Officer Creamington, I would not be stopped in my addiction and I would defiantly smoke anything I could get my hands on in: cigars, cigarillos, pipes, snorfs, creethens, half zappas, whole zappas, even railroad deggers. I felt quite the rogue. It was exciting. This picture was taken by my friend Michael in our hiding space.

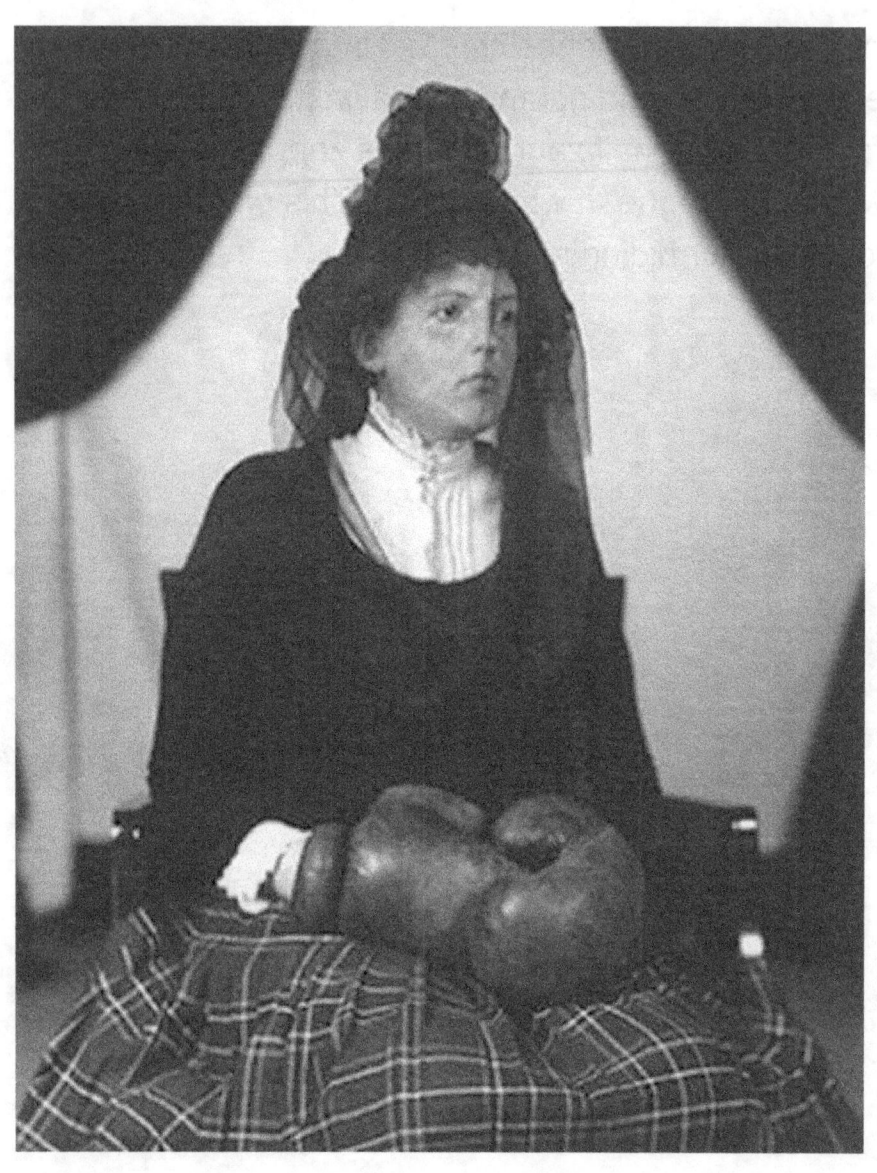

Mother was well informed about her rights, and would never have them questioned. She had enhanced methods of getting her point across. Firm. Solid. Grasping.

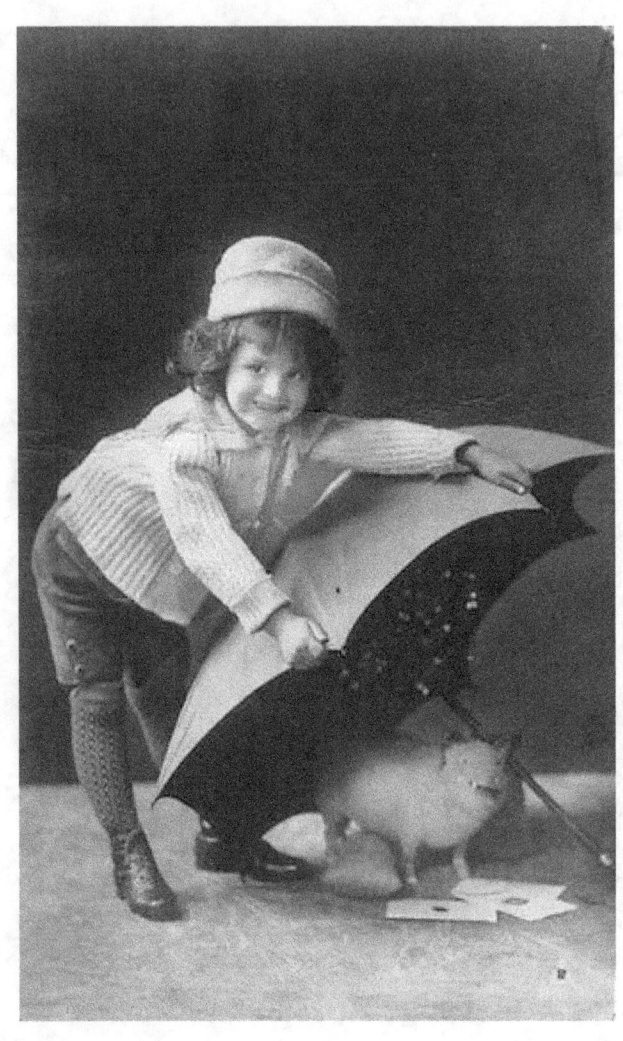

I sometimes amused myself in trying to change the weather. I succeeded once: a tornado in Kansas. With me is an important doctor who specialized in meteorology. His fee was high, but he always provided the important data .

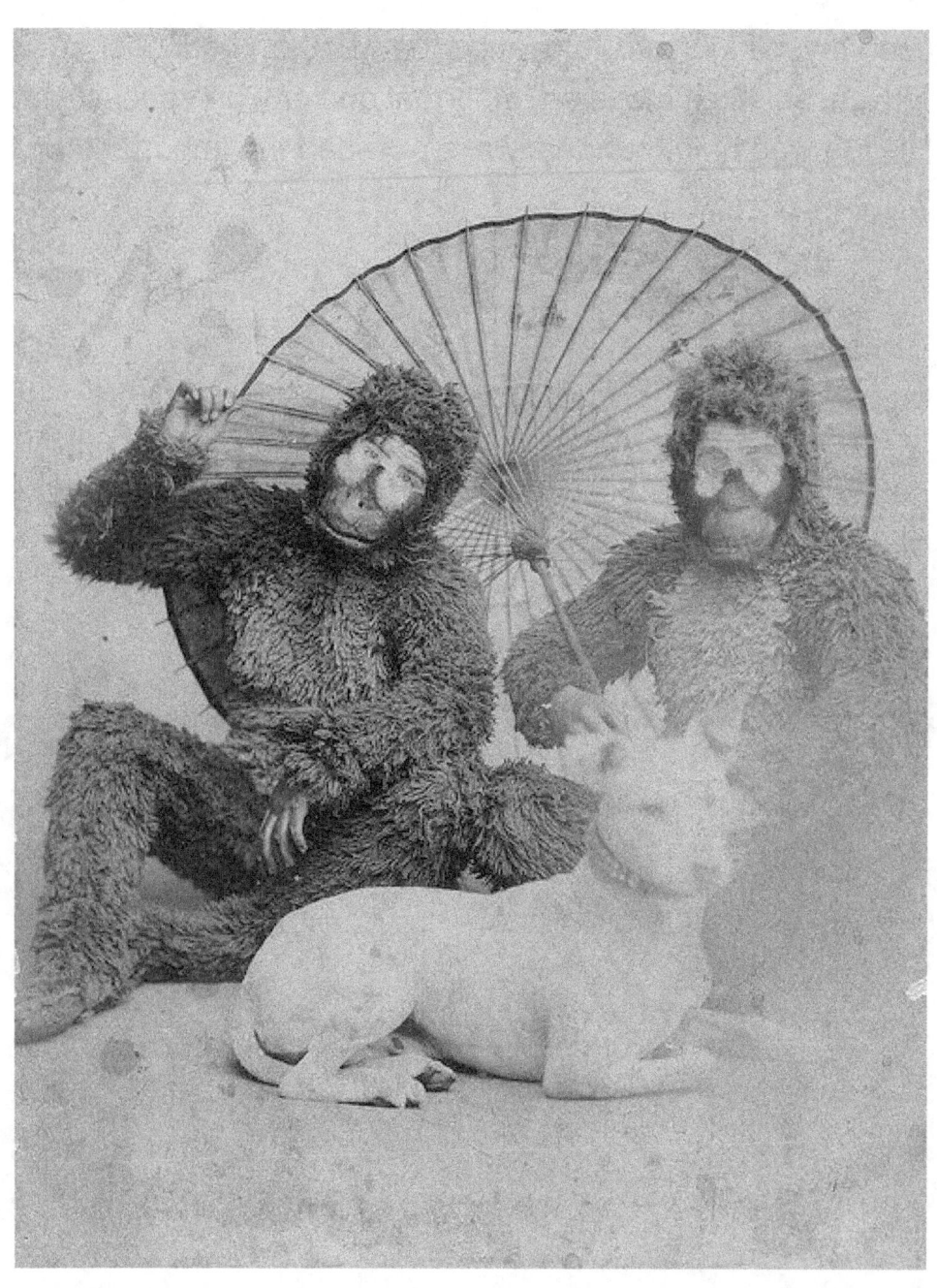

I was feeling rather snide in this photo. My brother had hemophilia.

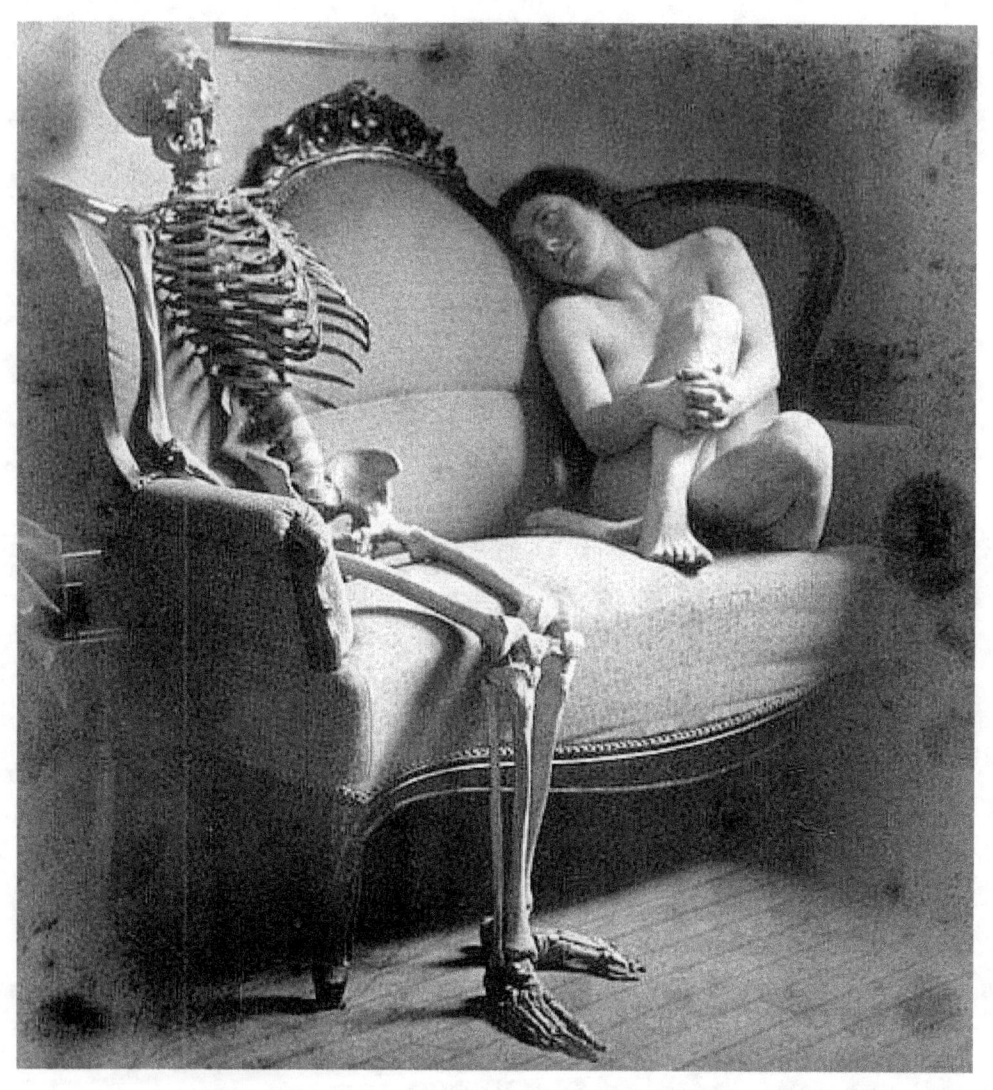

Uncle Ossie considered himself somewhat of an artist. His work was even praised by Alfred Stieglitz, but he never took it up professionally.

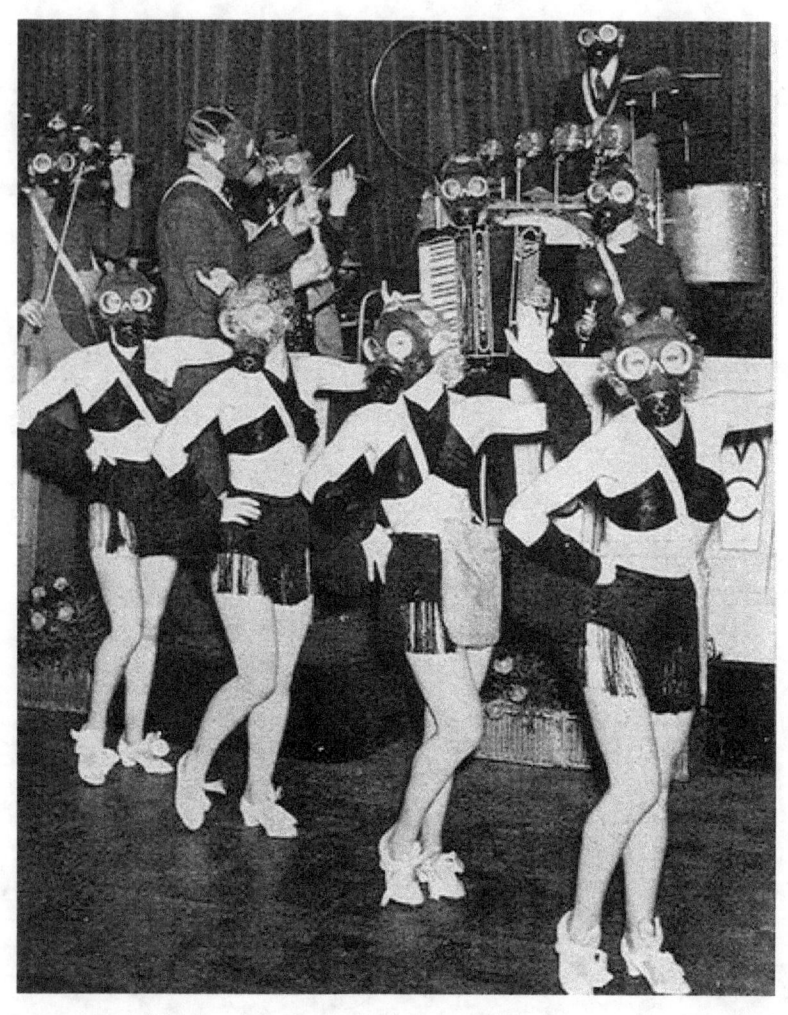

Mother at one of her business meetings. Afterwards they all had breast cancer screenings. It wasn't a lucky day for Julia.

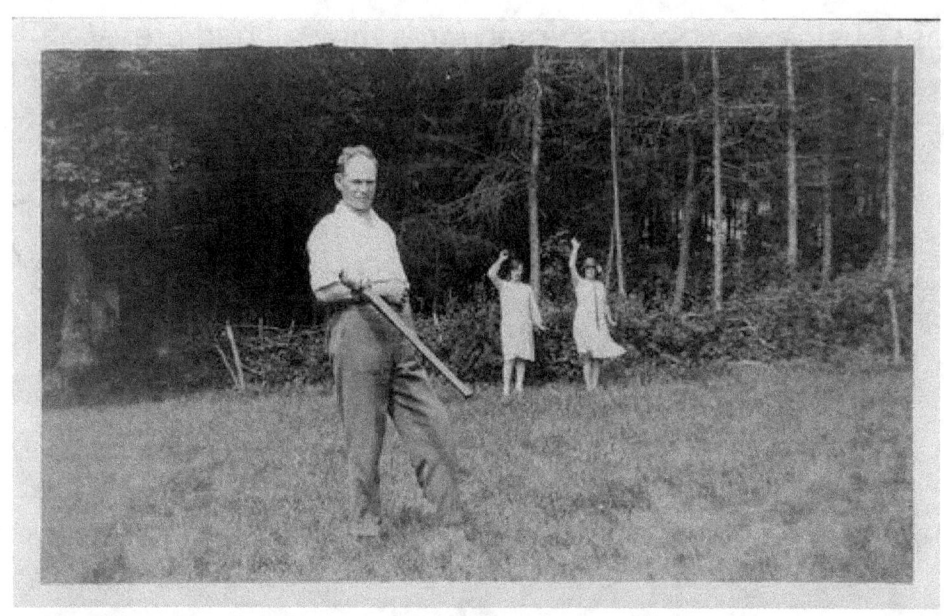

Uncle Gravid on one of his hunting trips. Strange animals were always following him around.

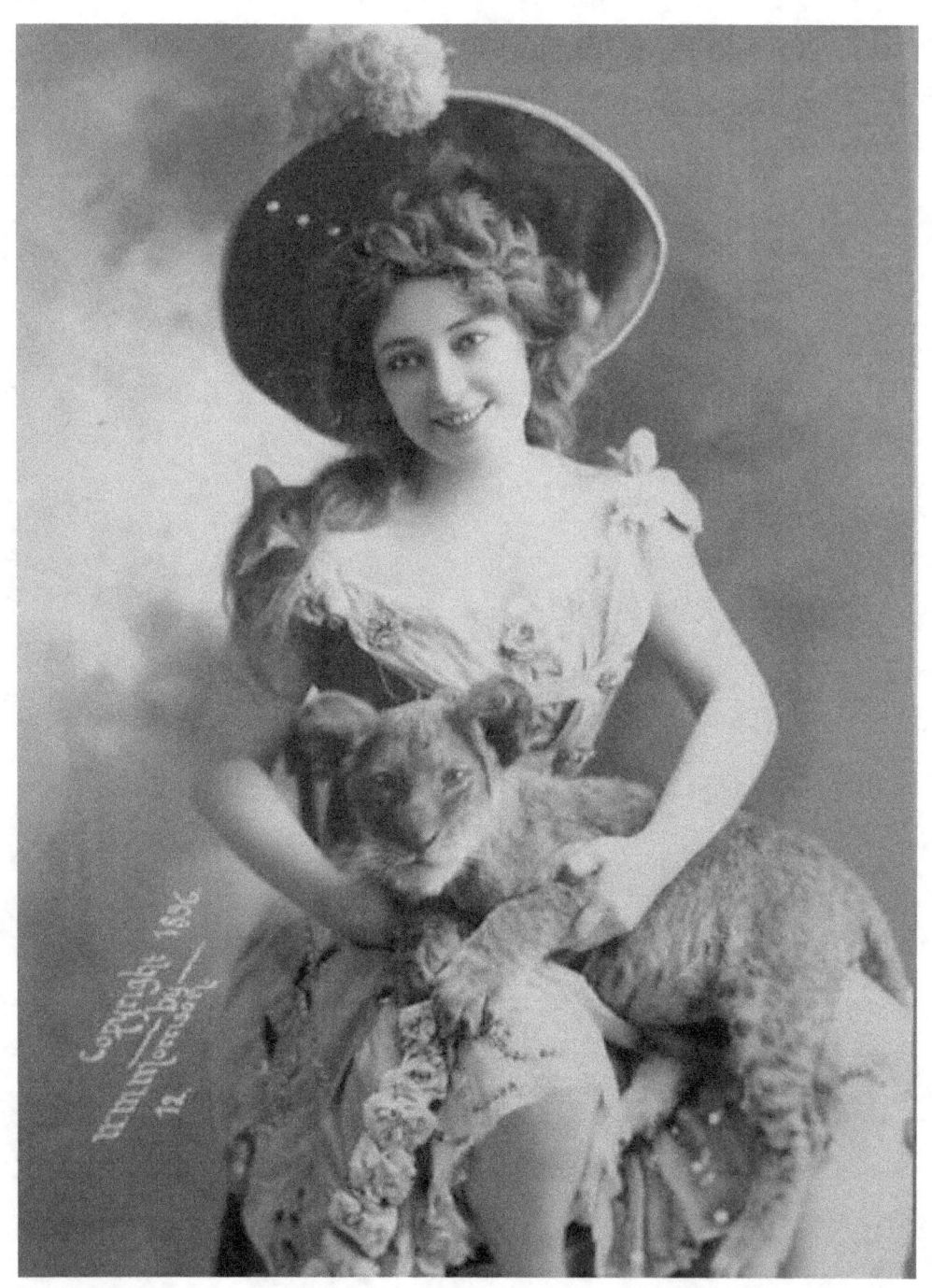

Mother holding my older brother when he was a baby. I wasn't born yet.

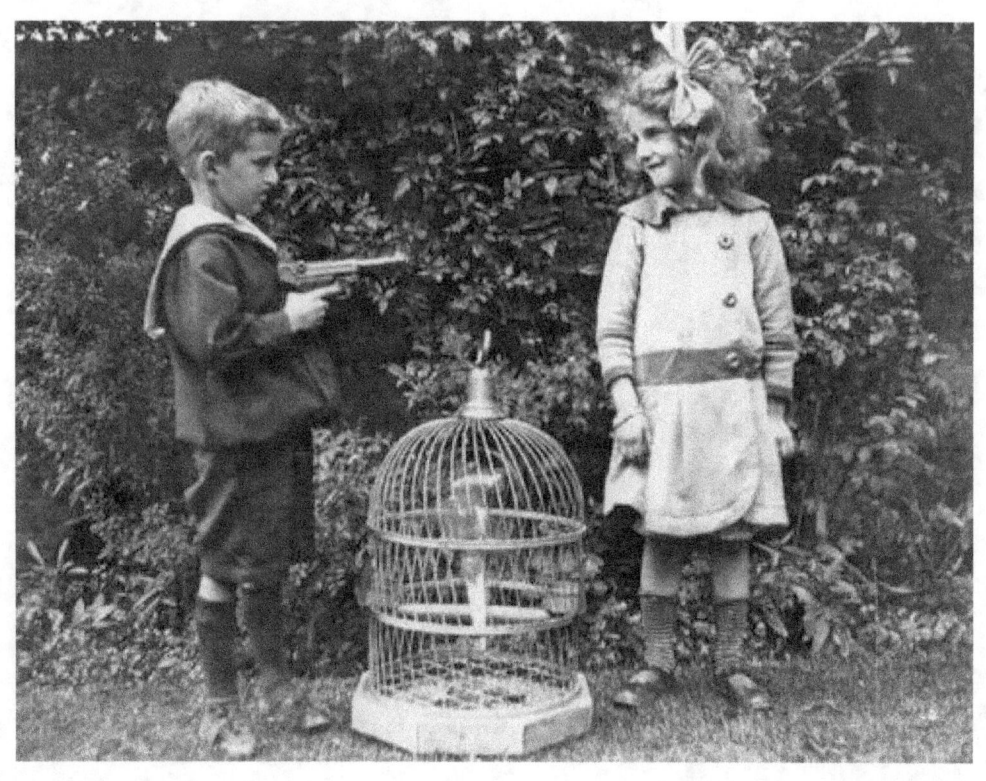

I could be a rather demanding child. Here I am with cousin Sue threatening her doll house. I planned on selling the structure for cigarette money but instead I ended up burying it in the backyard. There is a small patch of wild mushrooms in the spot now.

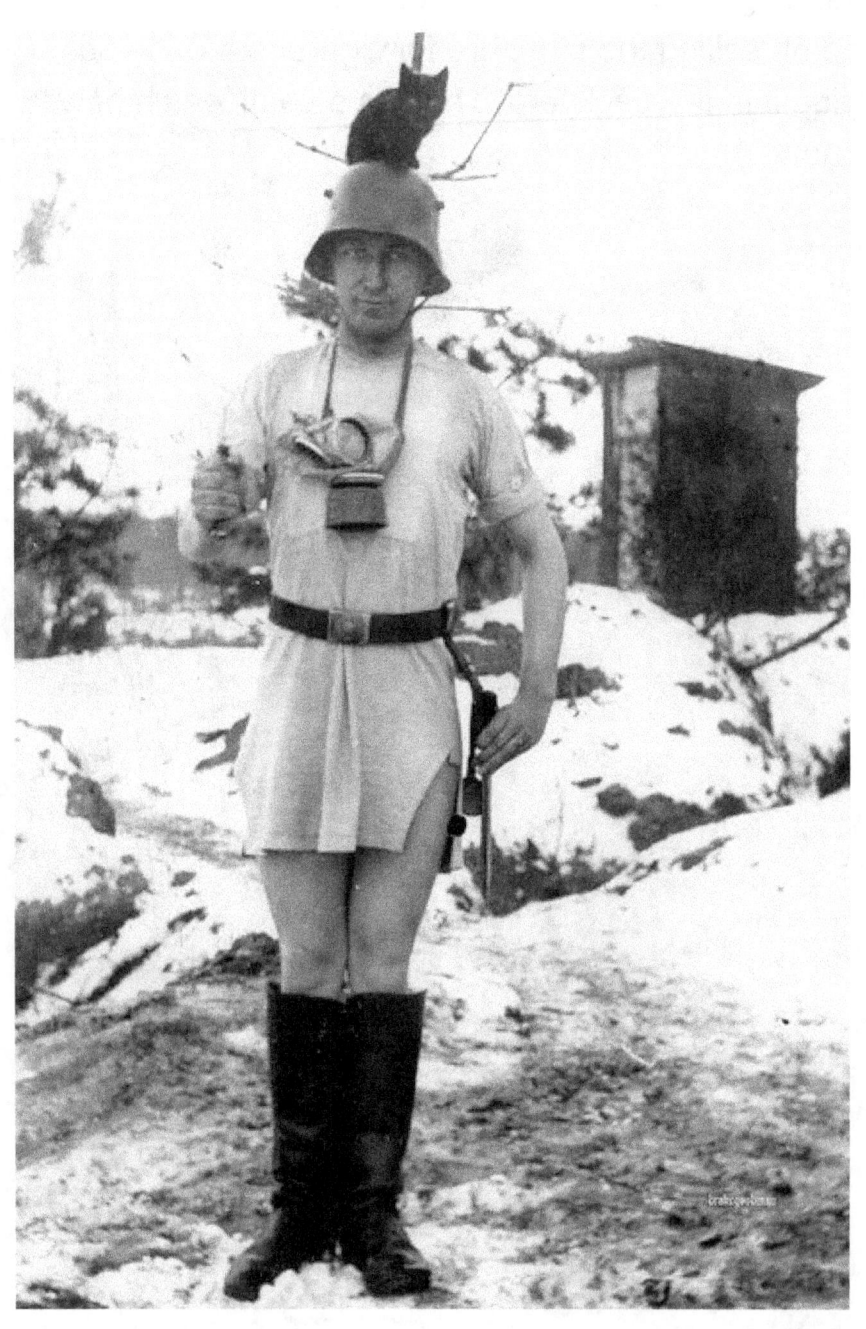

My brother heading off to college. He majored in accounting at first, but then switched to zoology. He works for a industrial mining company now.

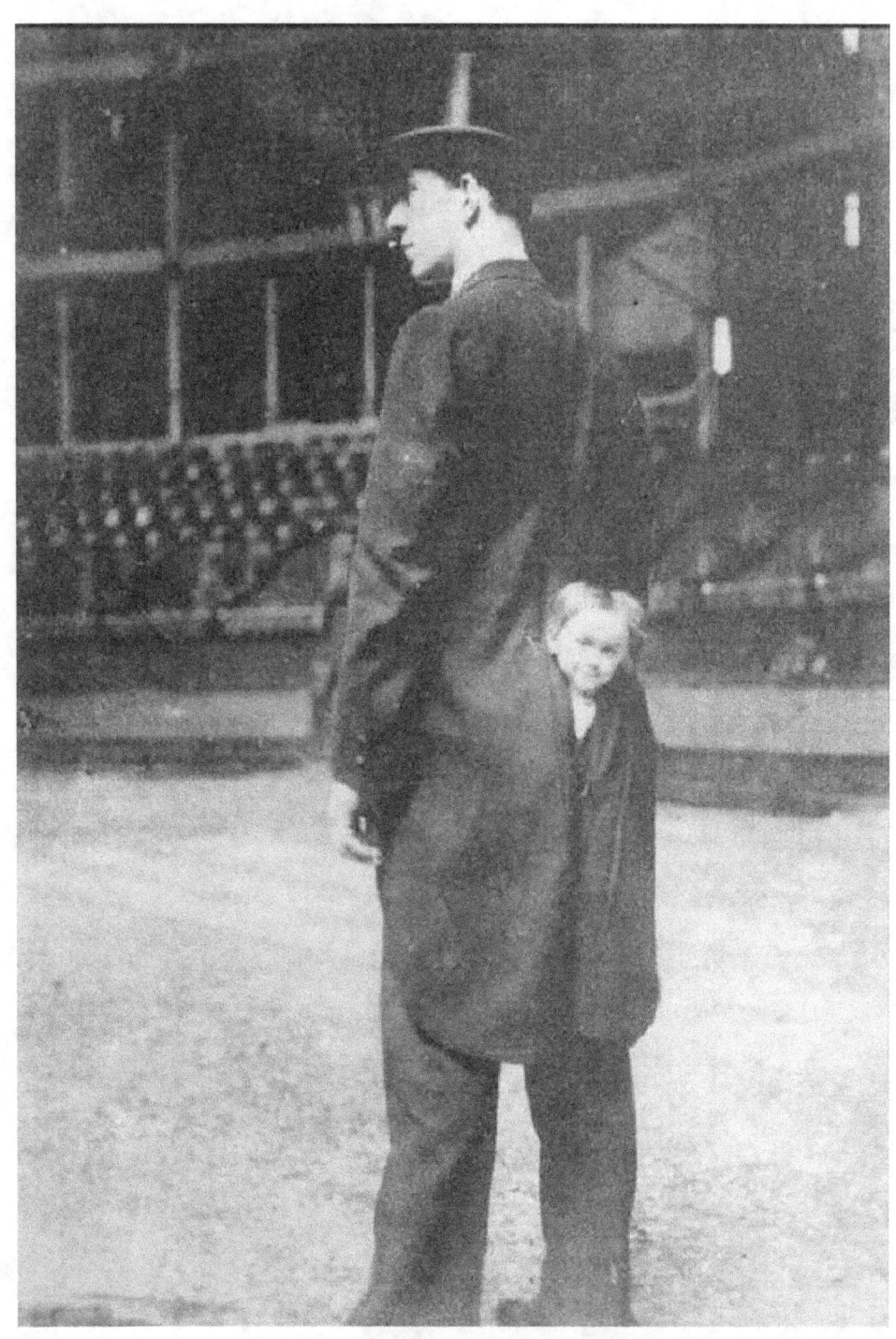

I lived in Berlin for a short period of time. I wore strange clothes and acquainted myself with...unusual persons. Here I am in my studio flat.

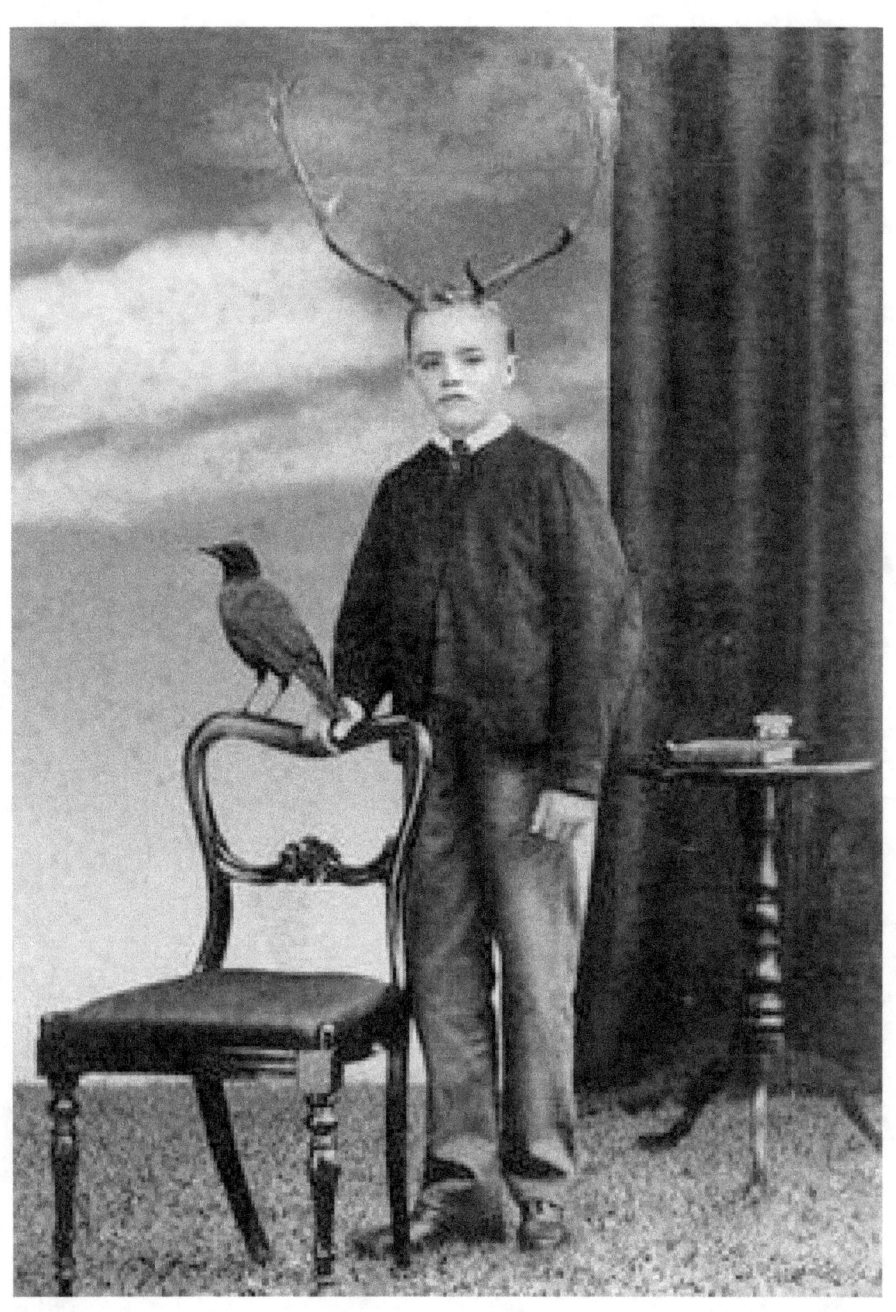

这张照片中的大家都死了。生活是恐怖

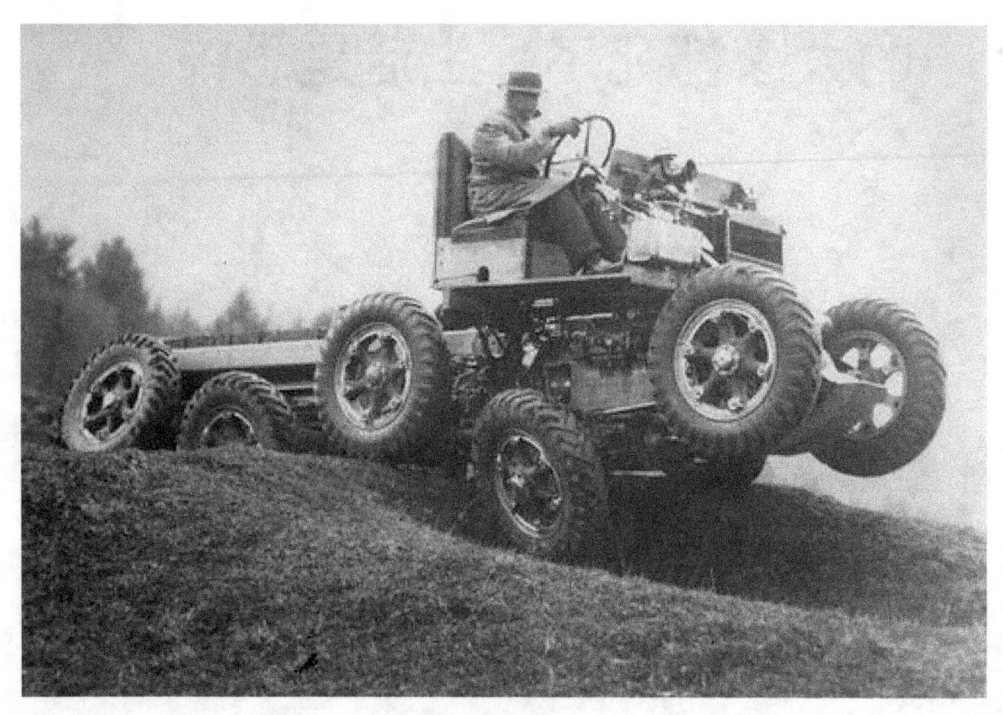

Cousin Phillip demonstrating one of his inventions. He called this one "Lucy" and it made the best toast in West Virginia.

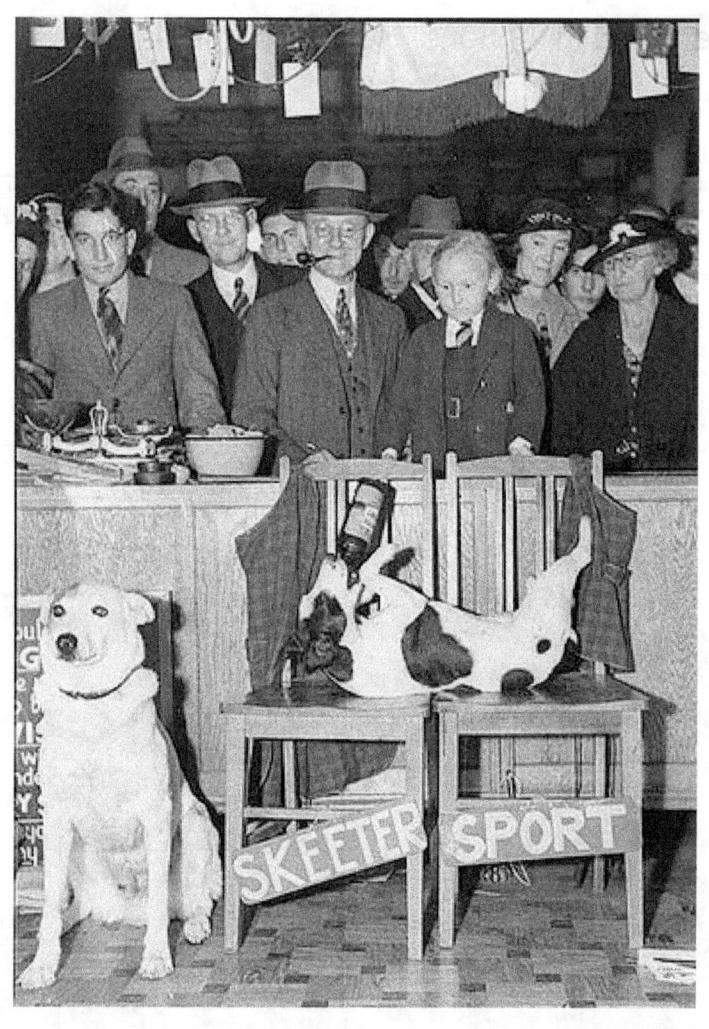

Father was often engrossed in his job.

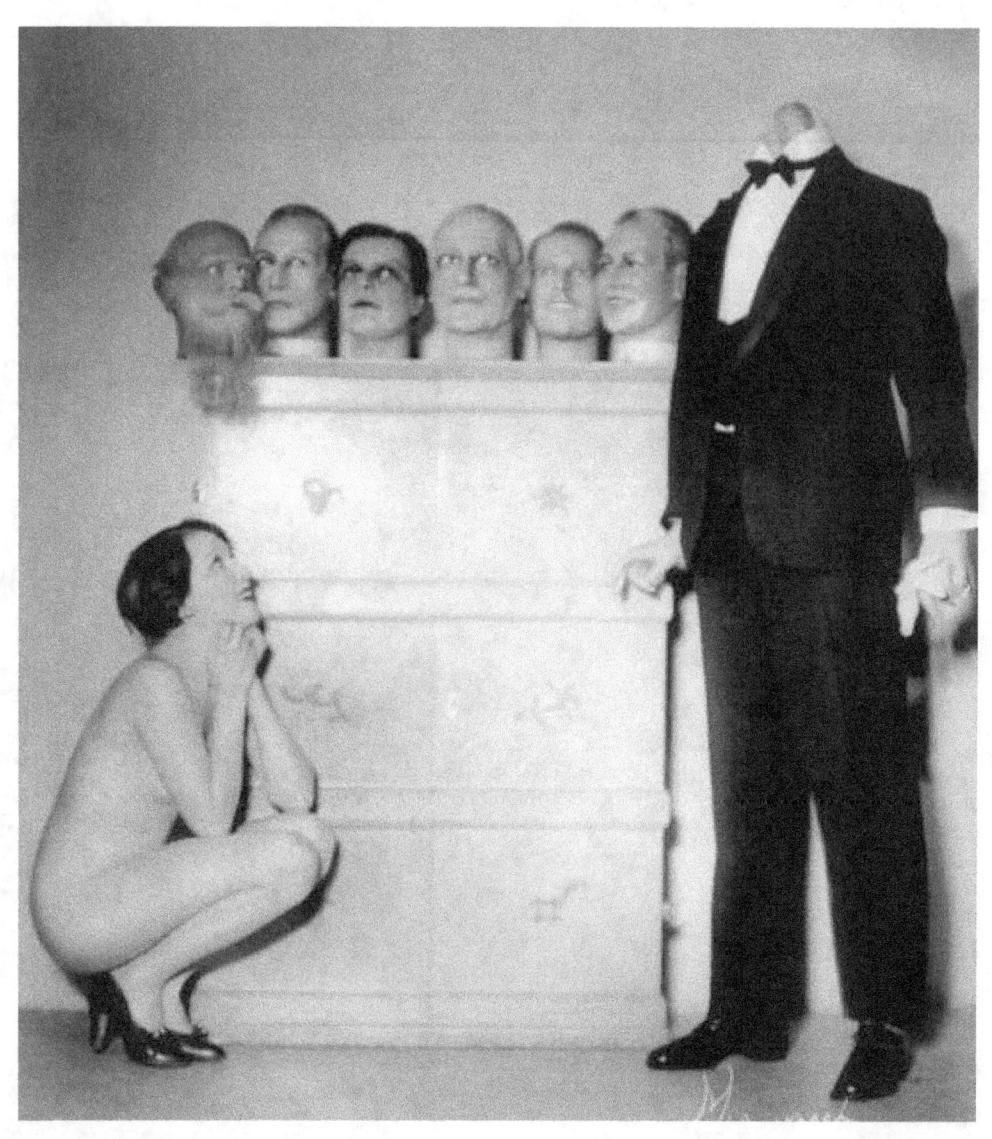

My parents' engagement photo. They were married in the foothills in June; the magnolias blooming and the moon shining.

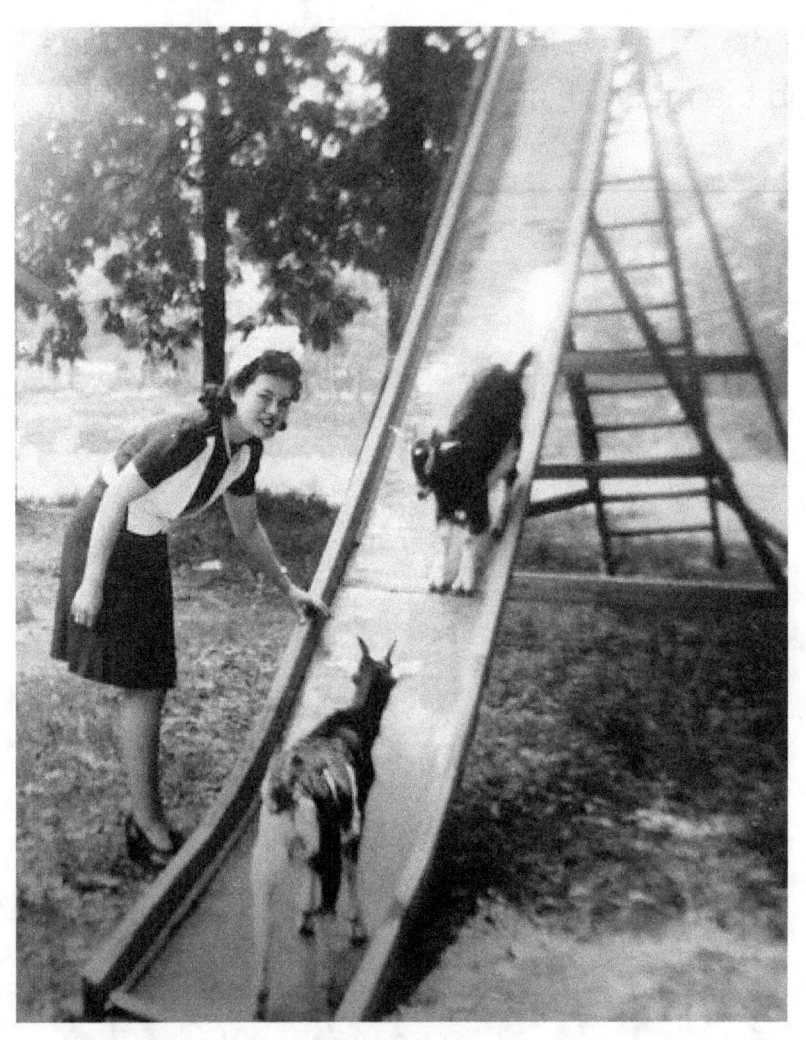

My brother and I helping mother wash the dishes.

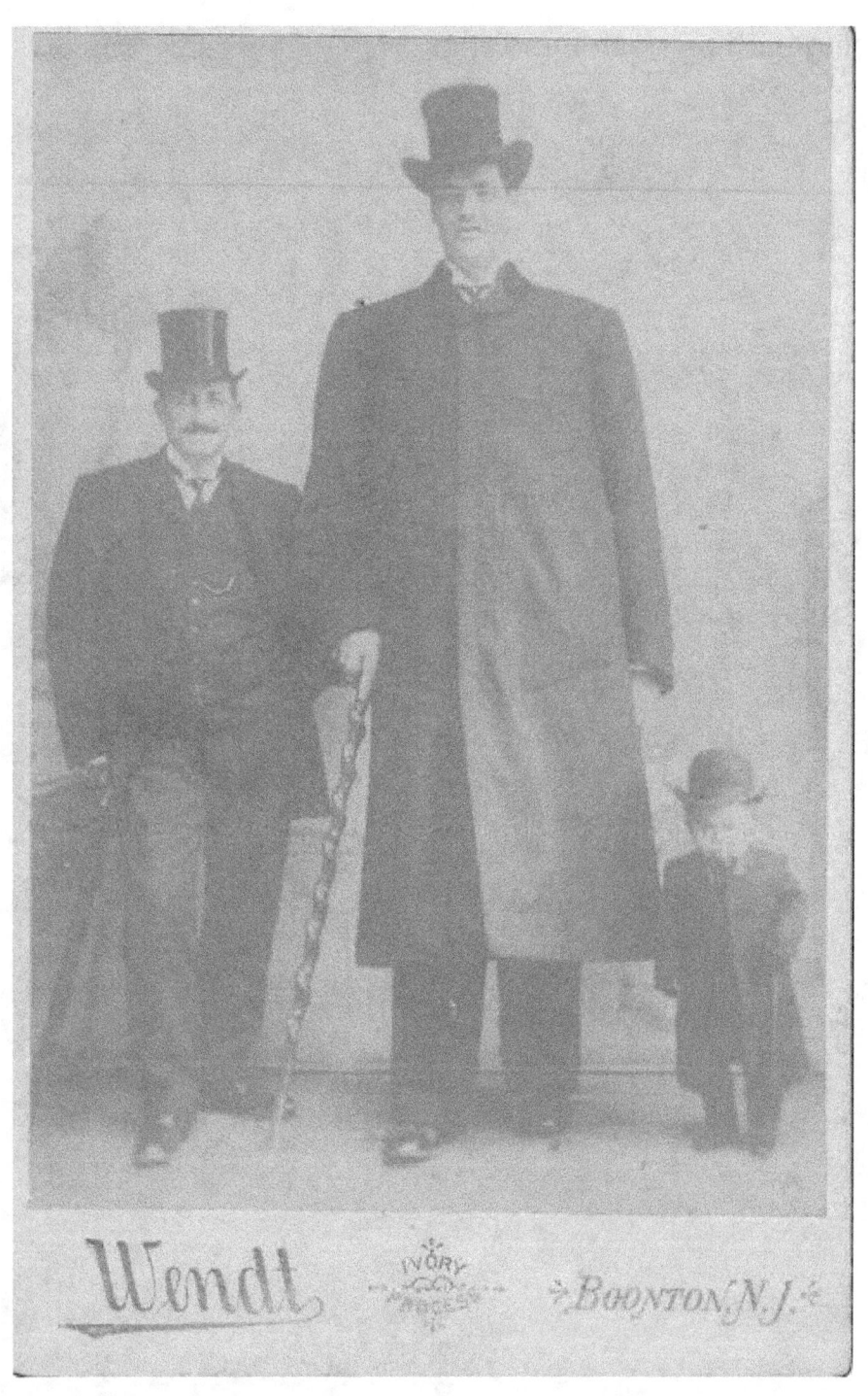

Father was a giant among men. Here he is with several of his co-workers. He worked at the Wendt manufacturing center where they fabricated and sold pianos, ice creams, shoes, human kidneys, and excuses.

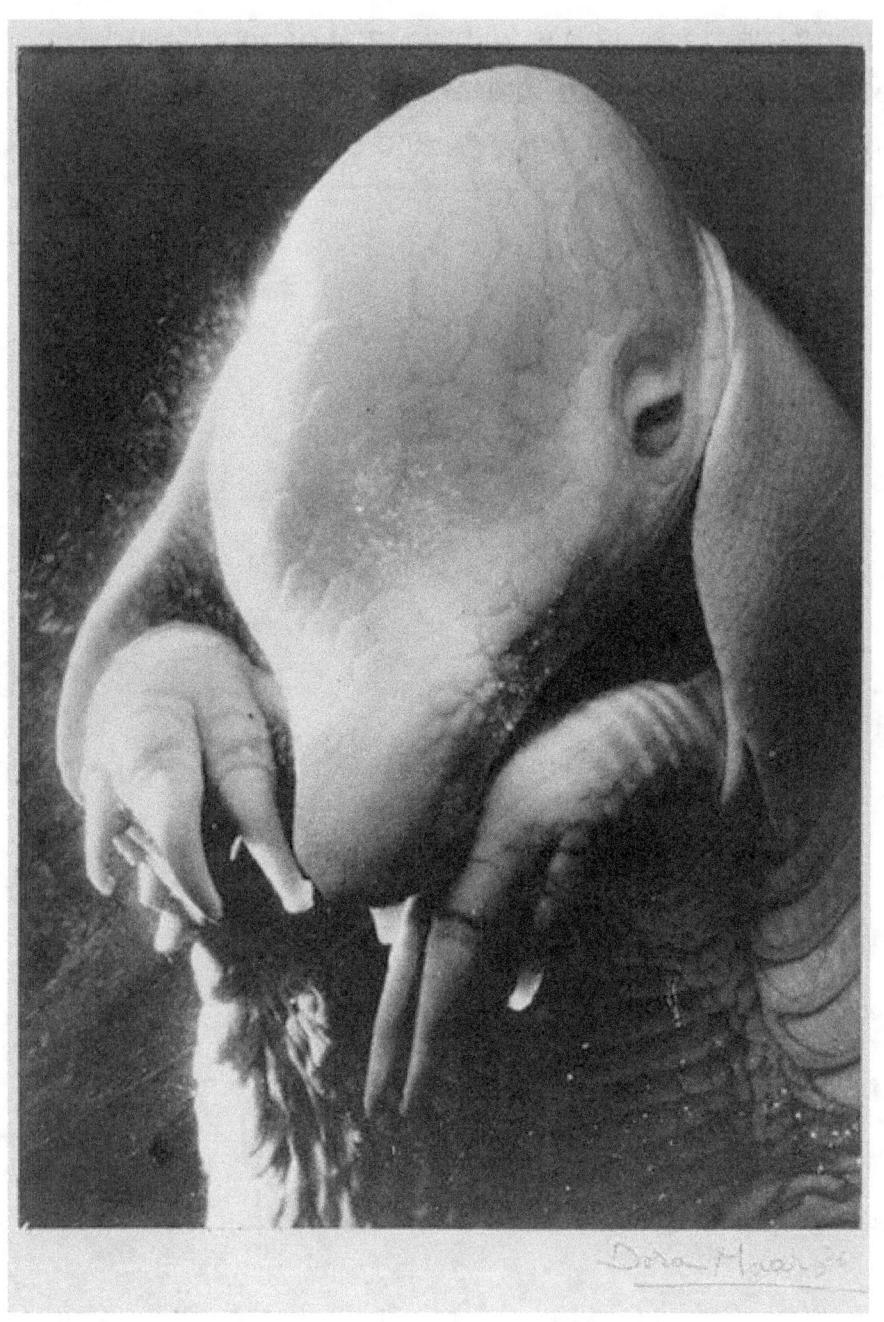

Me as a newborn.

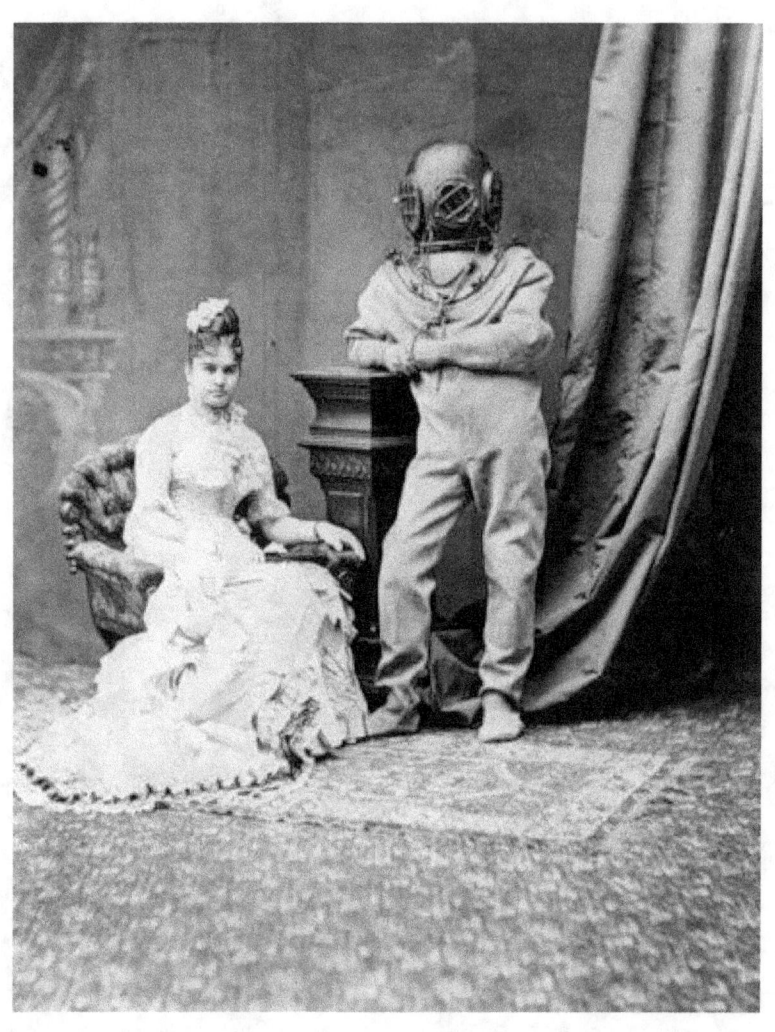

My brother on prom night. I remember his date was Brenda Makalaka. She went on to marry a railroad tycoon.

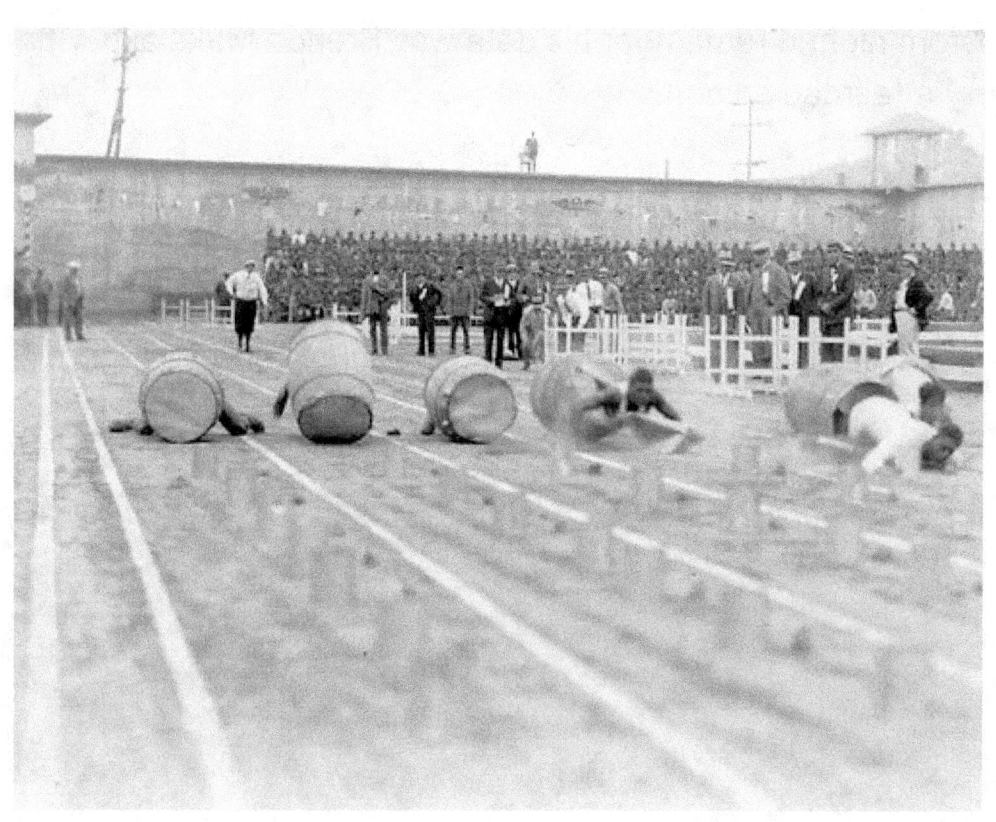

Getting our presents on Christmas Day. This was the year I got the pinball machine. I still have it.

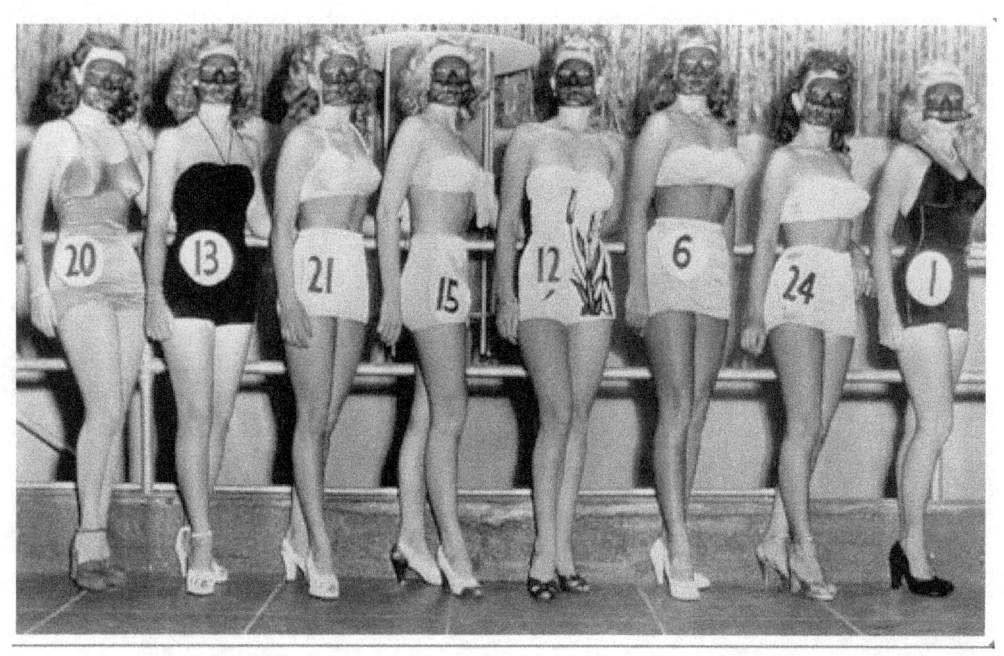

生活没有意义

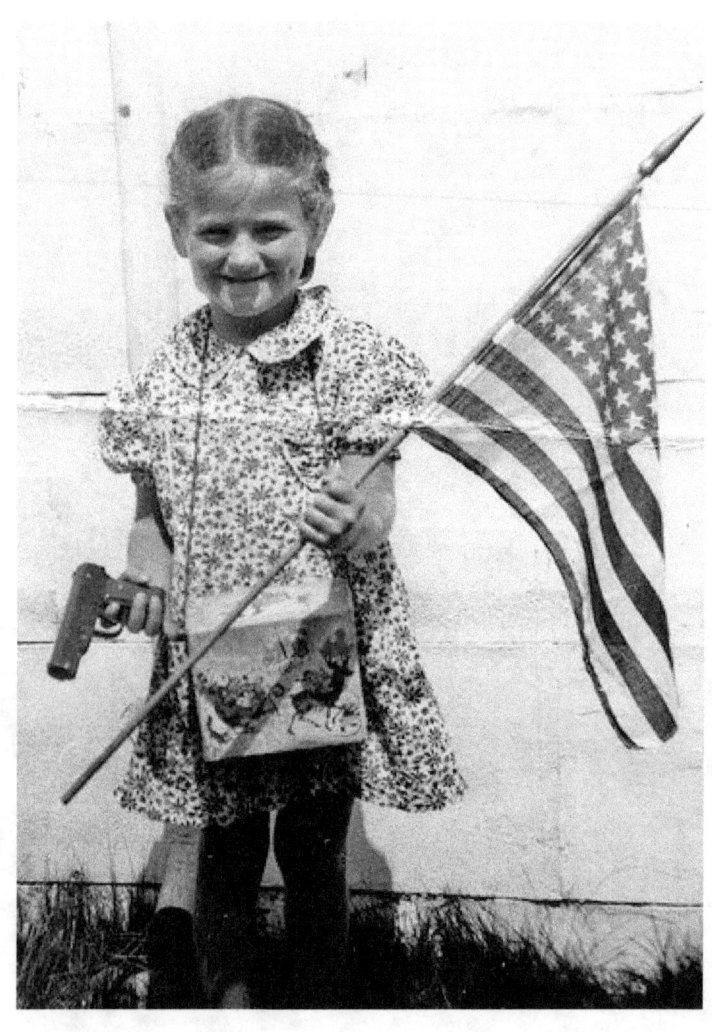

My little sister with her two favorite pets. The one on the right, Maxine, developed distemper and had to be put down. The one on the left, Sam, ran off to the woods and we haven't seen him since.

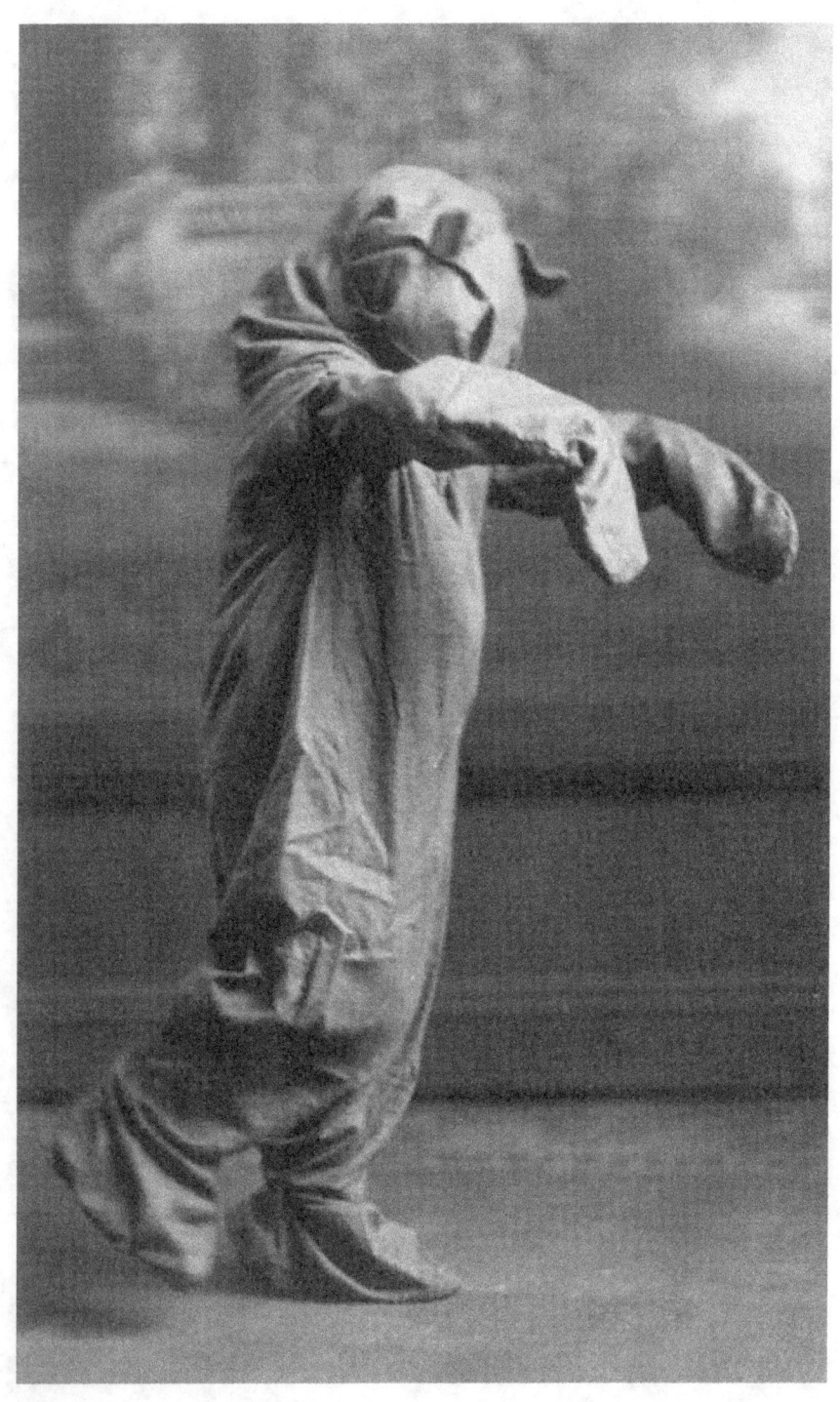

Father when he was angry.

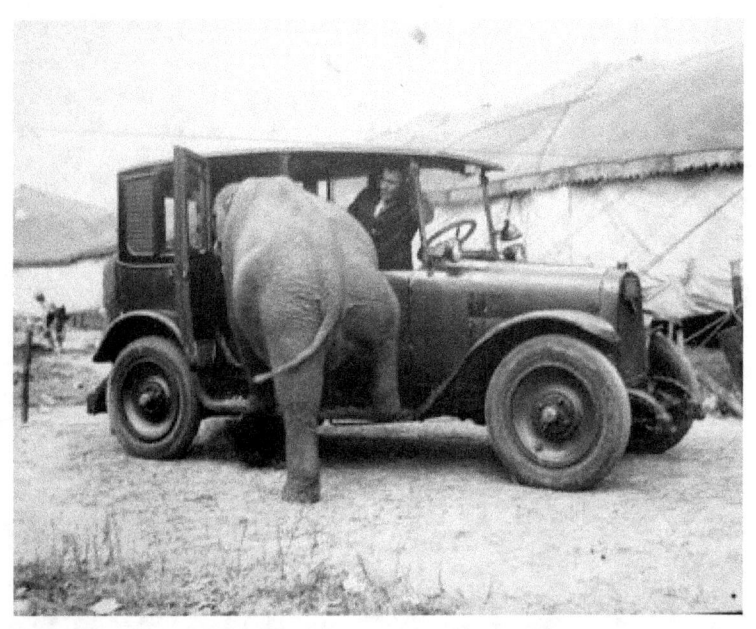

A typical Sunday breakfast. As usual Charles was being greedy.

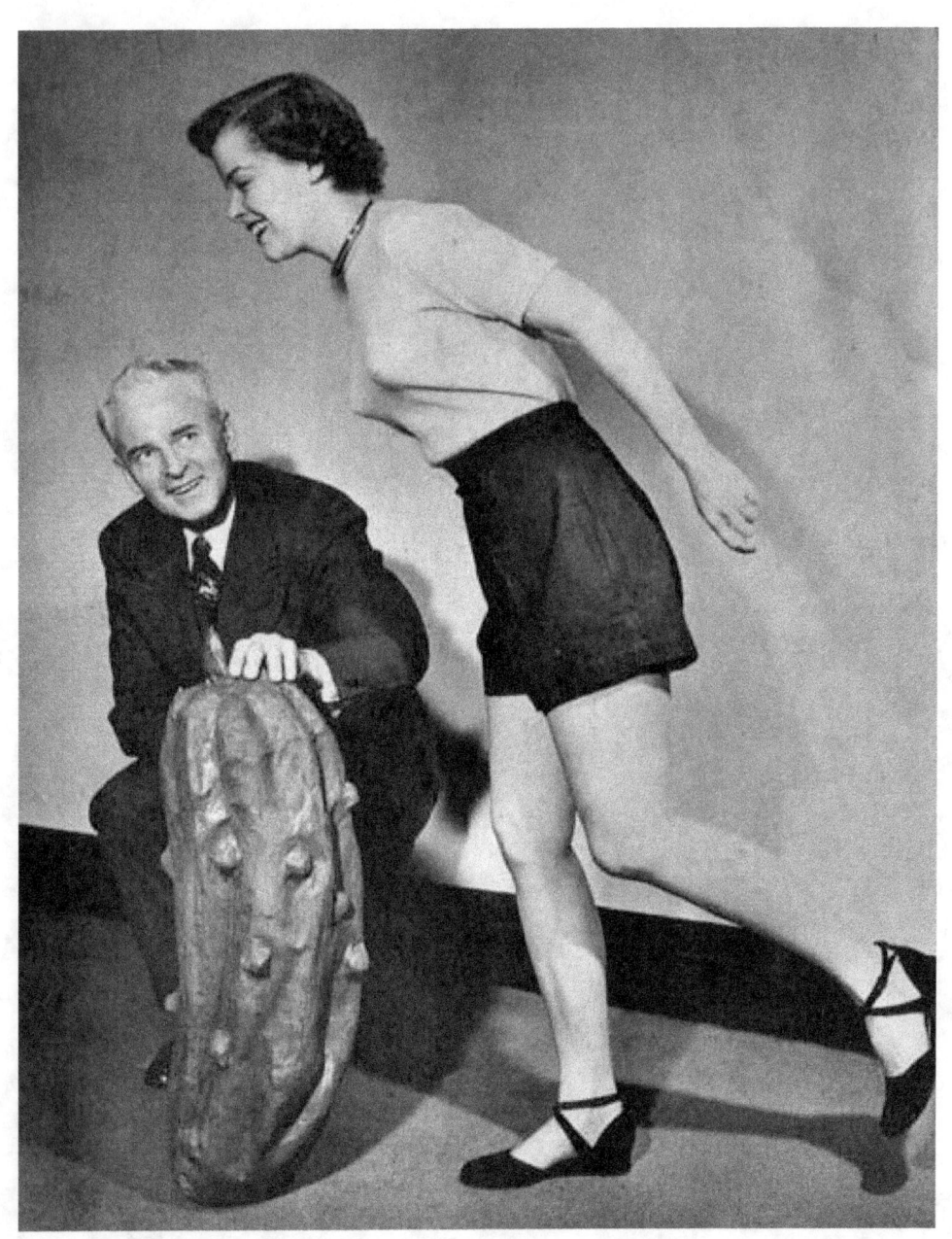

My brother being reprimanded for his naughtiness.

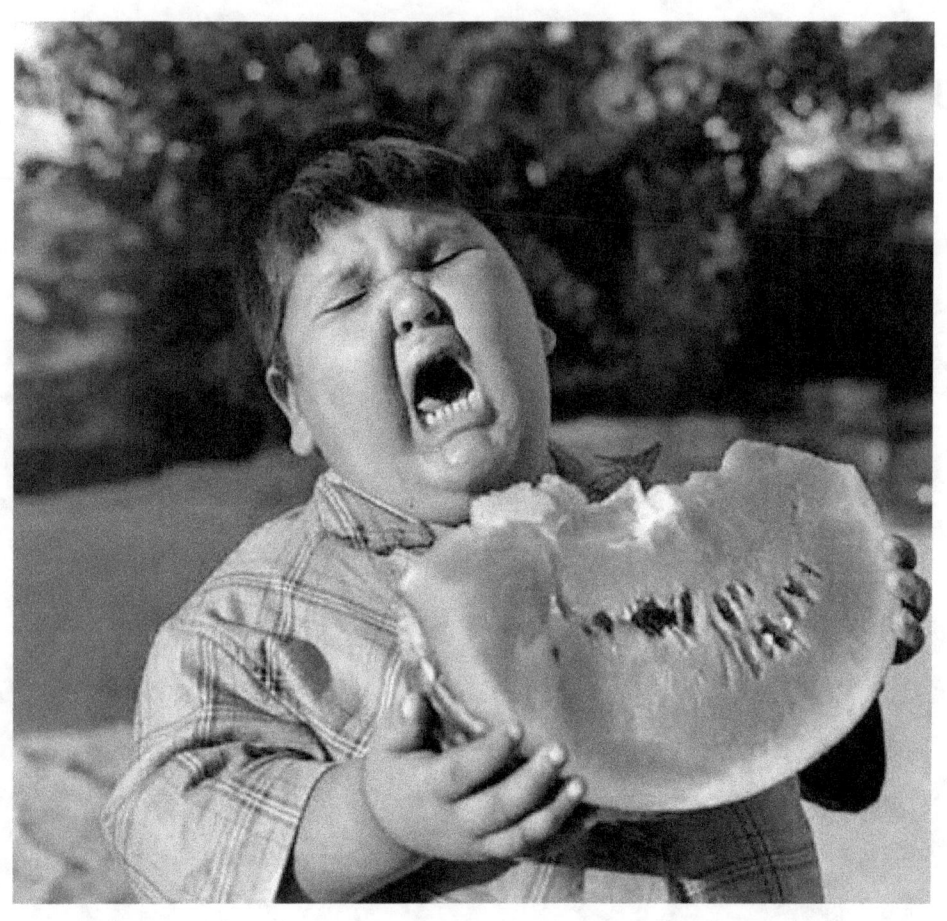

Uncle Blister holding a newborn calf in his hands. Uncle Blister owned a huge farm upstate. He died when I was very little, so I don't have many memories of him.

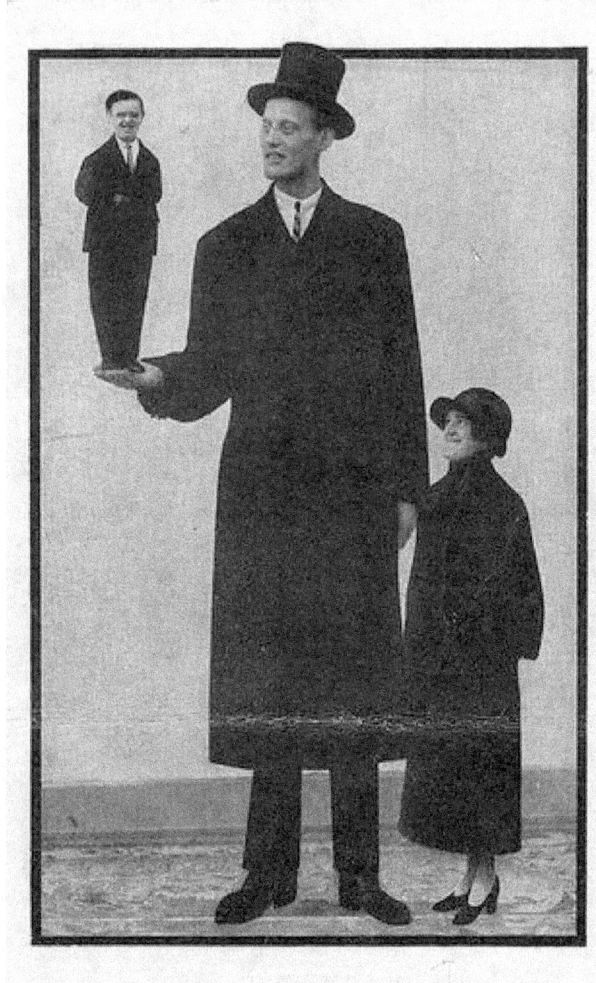

Father displaying feats of strength when he was younger man.

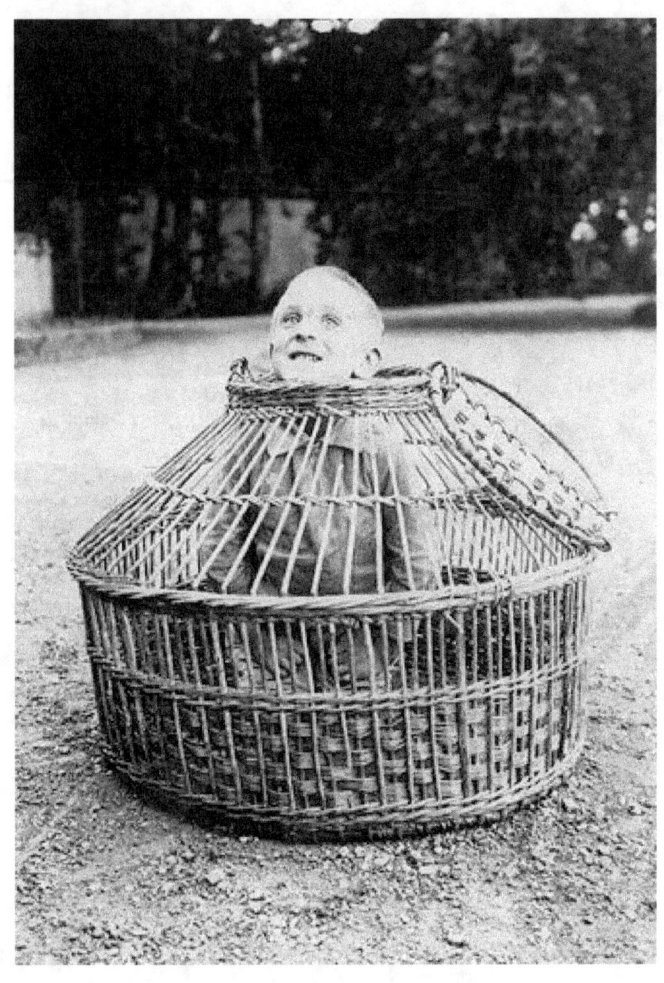

Me in one of my many hiding places. This picture was taken in Russia.

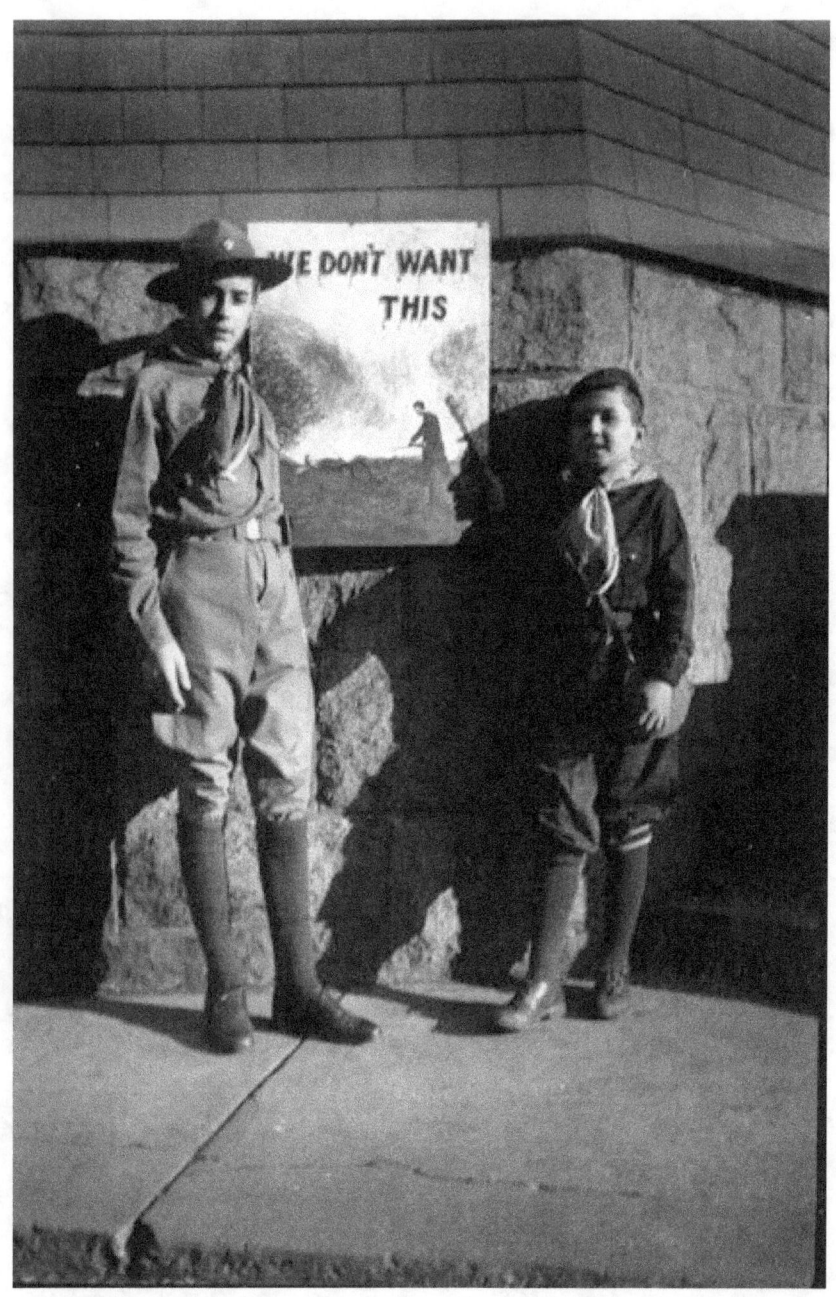

A picture of my brother and I playing the lying game

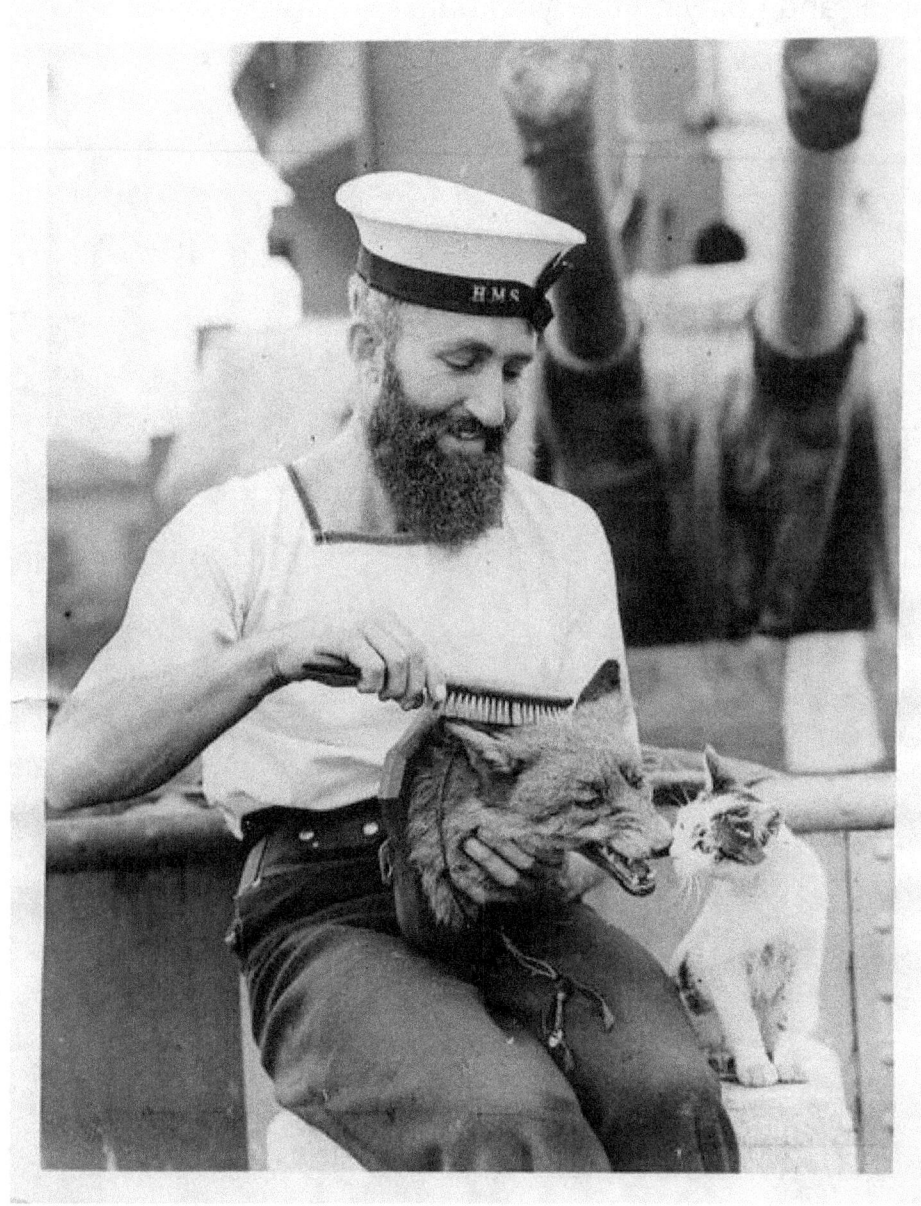

Cousin Phillip holding my newborn baby sister. He had just got home after 8 years at sea.

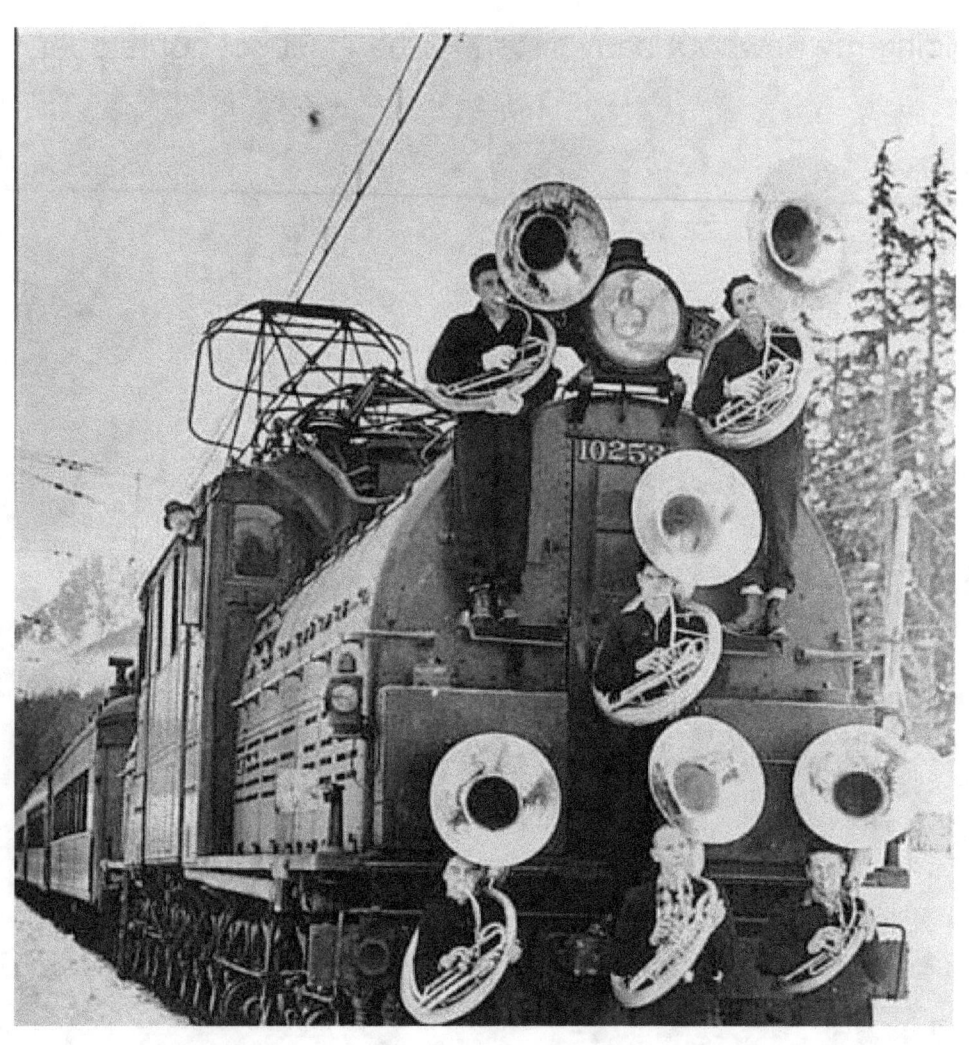

My family got to meet President Taft when father went on a business trip to Washington. Mr Taft was a nice man and he smelled like cigar smoke and almonds.

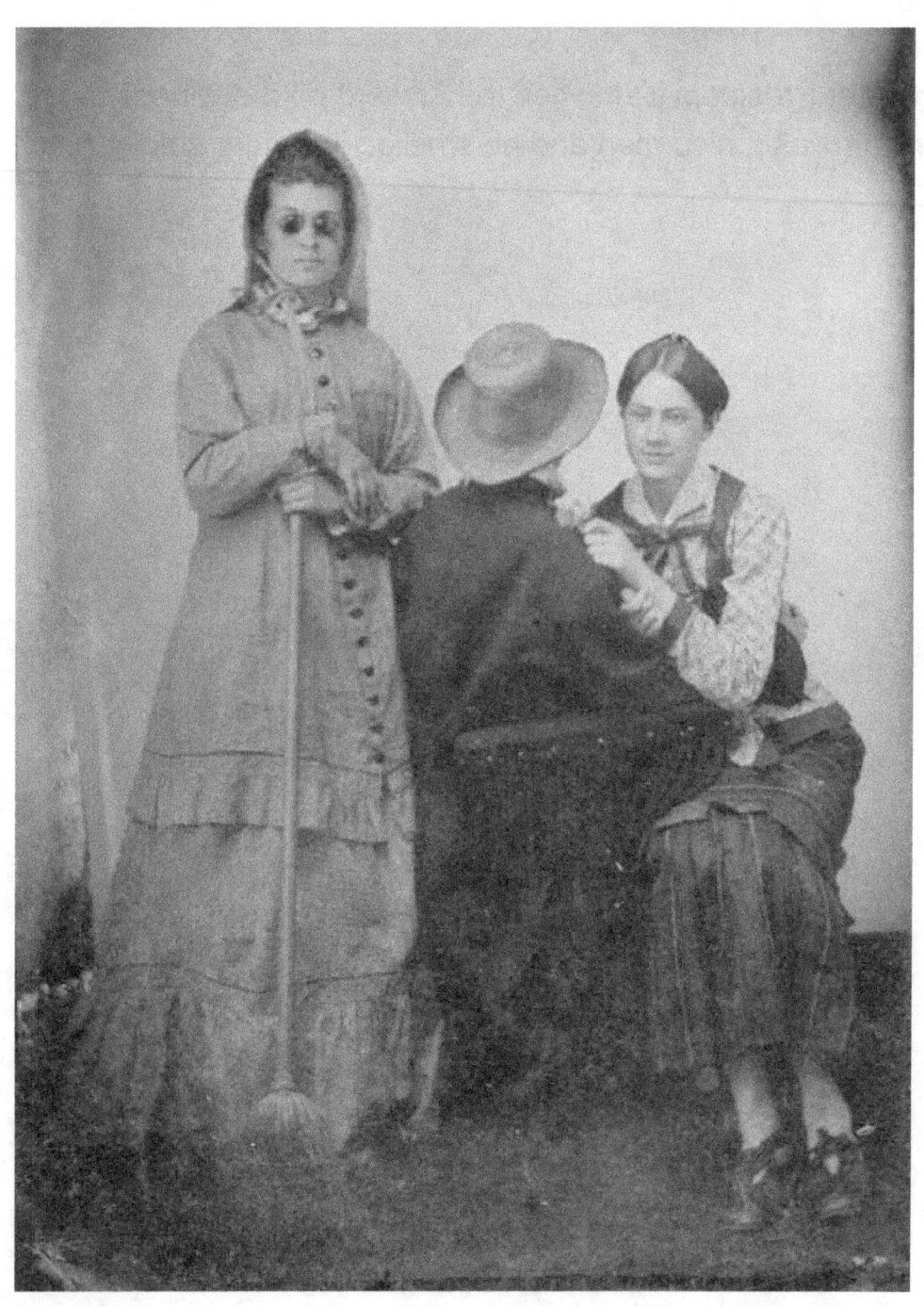

Grandma Milk at the time of the war.

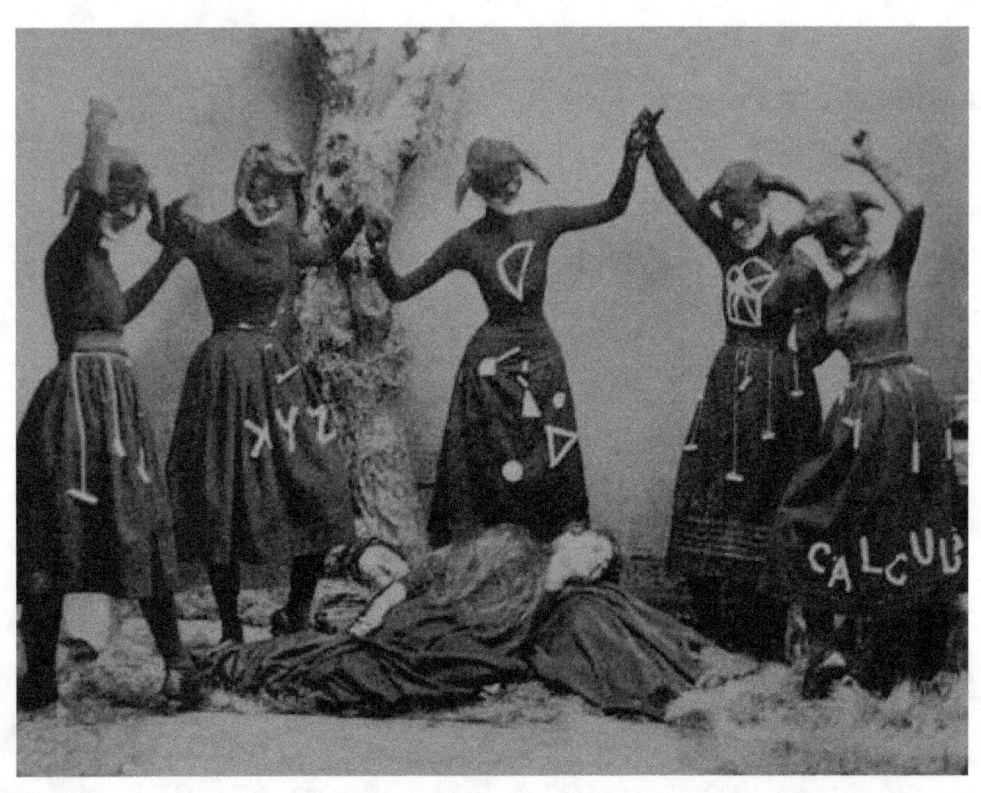

My high school algebra teachers were very strange.

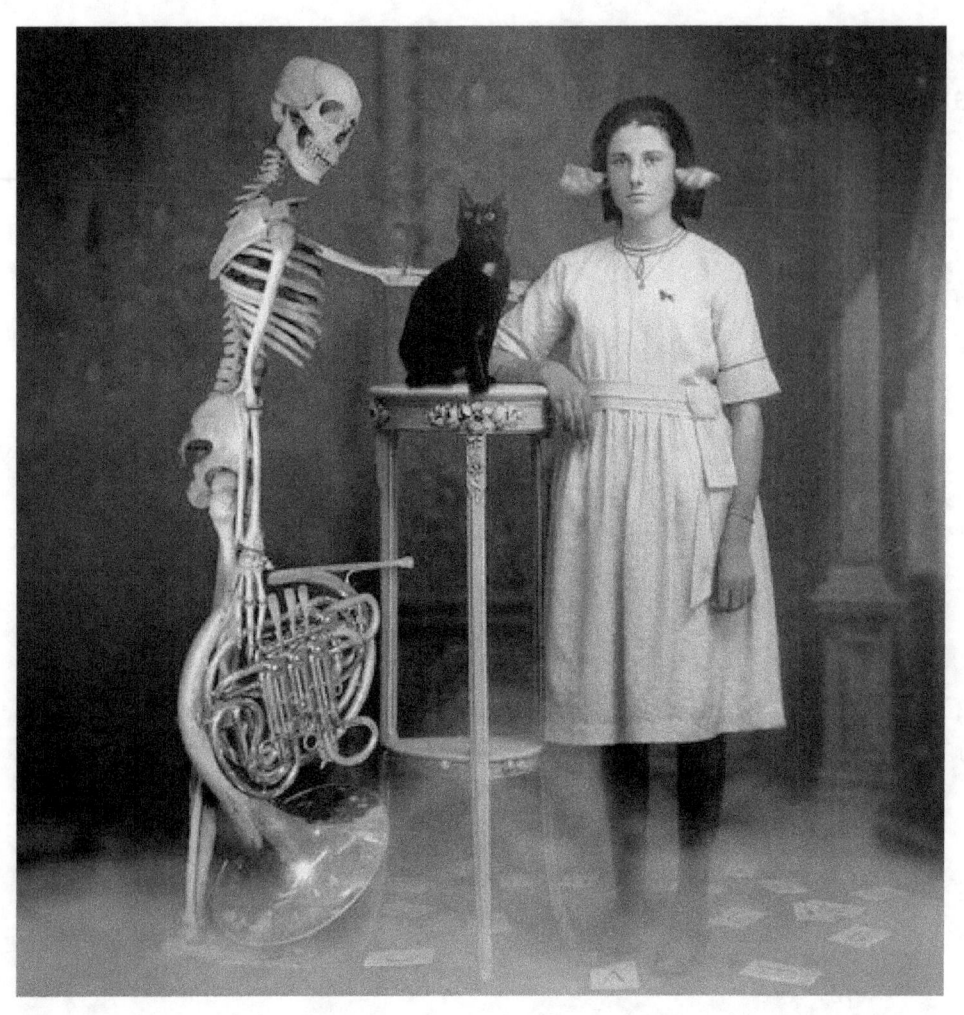

A picture of Uncle Ossie and his family: his two sons, max and peter, and his wife Claudia.

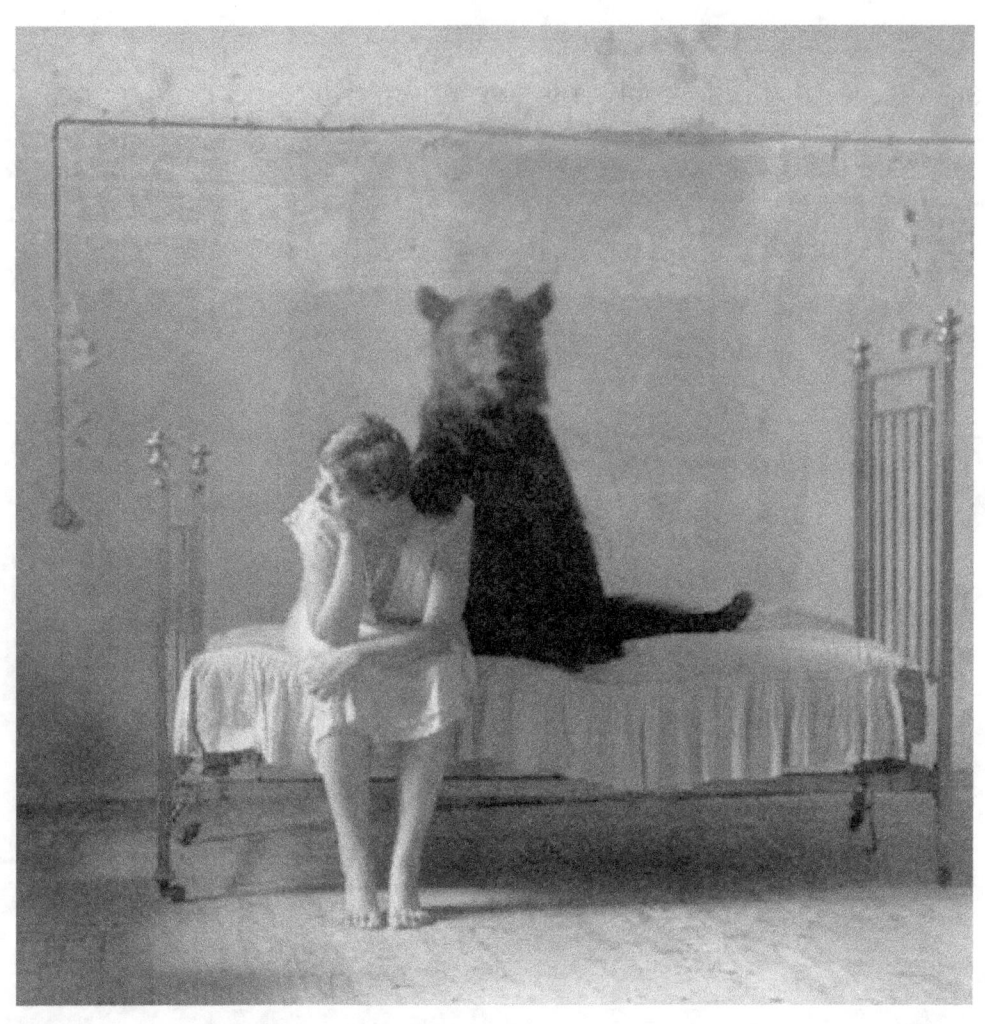

My little sister on her first date. All i can say is that it did not go well.

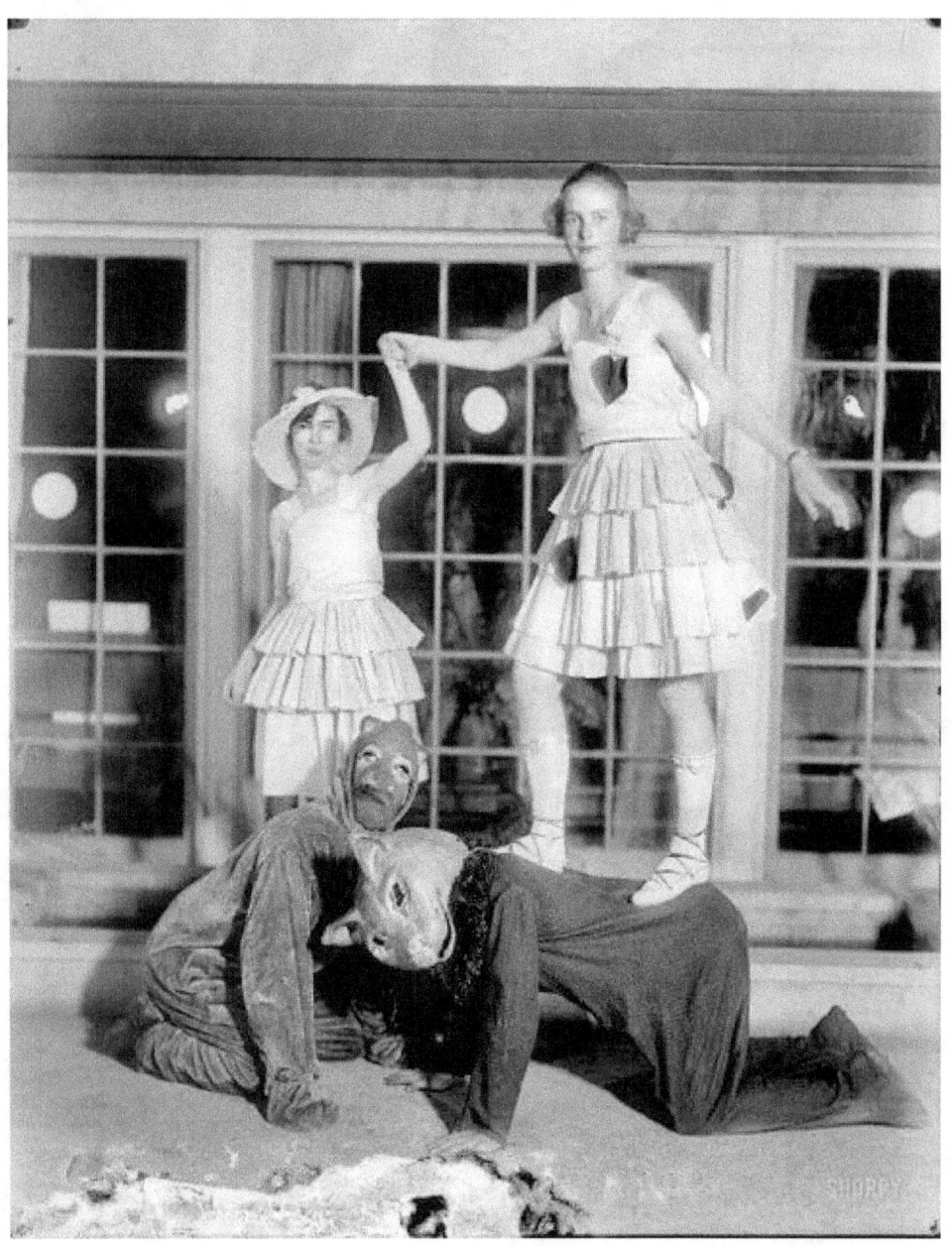

Father receiving his weekly chiropractic treatment.

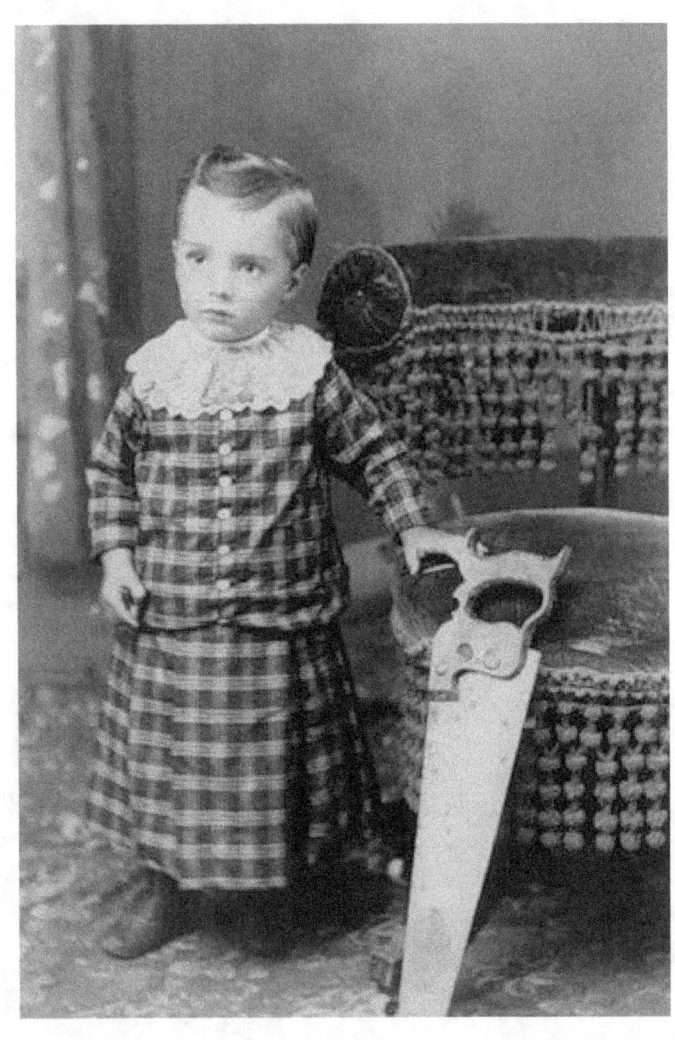

My brother and I, being saucy as usual.